BRITAIN'S 🏰 HERITAGE

The Seventies Railway

Greg Morse

AMBERLEY

Acknowledgements

I am indebted to Roger Badger, Derek Hotchkiss, Philip Hunt, Mick James, Julia Jenkins, Gerald Riley, Debbie Stevens, Michael Woods and Nick Wright.

My thanks also go to those who supplied many of the images in this book: Colour-Rail (incorporating the work of the G. Parry Collection, D. Pye and A. Price), Rail Photoprints (Hugh Ballantyne, Andrew Beavis, Ronald F. Collen-Jones, John Chalcraft, David Cobbe, Peter Dobson, Gordon Edgar, John Medley, the Pathfinder Tours Archive Collection, Les, Peters, Richard Priestley, Graham Smith and John Vaughan), Getty Images, Colin J. Marsden and STEAM Museum, Swindon.

First published 2018

Amberley Publishing
The Hill, Stroud
Gloucestershire, GL5 4EP

www.amberley-books.com

Copyright © Greg Morse, 2018

The right of Greg Morse to be identified as the Author of this work has been asserted in accordance with the Copyrights, Designs and Patents Act 1988.

ISBN 978 1 4456 7224 3 (paperback)
ISBN 978 1 4456 7225 0 (ebook)

British Library Cataloguing in Publication Data.
A catalogue record for this book is available from the British Library.

Printed in the UK.

Contents

1

Introduction – A New Decade Dawns

The sixties had been a bad time to be a trainspotter. What tears had been wept for the loss of steam? What laments sung for the loss of stations, lines, ways of life? It was all that Beeching's fault! That's what Dad said anyway, though you'd seen some of the story unfold yourself – mostly in the pages of *Modern Railways* or *The Railway Magazine*, with their pictures of Pacifics speeding through Surbiton for the last time in '67, their studies of steam bowing out for good the following year. And now? Now, you stand at Sheffield Victoria. Actually here, actually cold this freezing January evening, looking out not for 8Fs, Scots or Black Fives, but for the last arrival from Manchester Piccadilly over the trans-Pennine Woodhead route, with its unique electrics, born in the days of the old LNER, when dinosaurs roamed the earth (at least as far as you were concerned).

Some of the older boys start to look worried and you wonder what on earth's going on. It's Valehouse, they say. There's been a derailment. They've sent the 21.20 over the Hope

At 00.44 on 5 January 1970, EM1 E26054 arrived at Sheffield Victoria with the last passenger train to work over the Woodhead route. After this, the service was withdrawn and the station closed. Two days earlier, 1,500 V DC classmate E26050 was captured near Bullhouse with a westbound working. (Rail Photoprints)

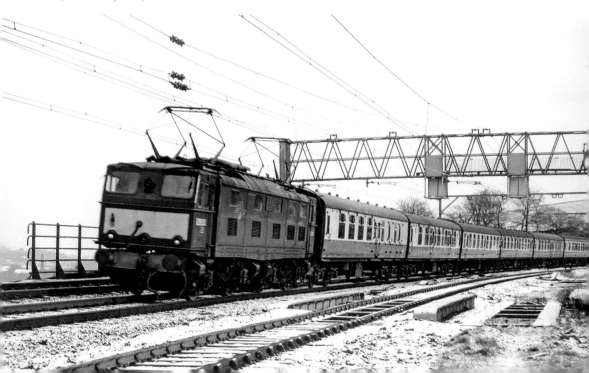

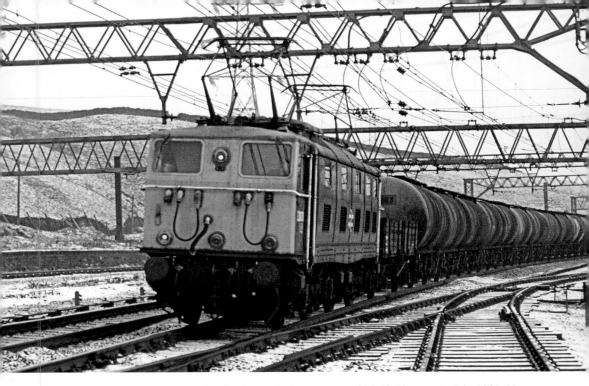

The Woodhead remained open for freight until closure east of Hadfield came in July 1981. Here, E26016 takes an oil train past Dunford Bridge in January 1970. (Rail Photoprints)

Valley line instead. There's a grumble. There's a rumble. There's to be a 'sit in' at the Station Master's office...

Many go. Most still stand and shiver. Not you. You have school tomorrow. You'll miss out. You'll never see E26054 and the 'special' put on to placate the platform-enders, never learn of how it had to reverse at Hadfield and run 'wrong road' to Torside before finally gliding in at a quarter-to-one on the Monday morning. Not until it appears in one of the magazines, anyway.

* * * * * *

Those same magazines had kept a watchful eye on the progress of British Railways – or 'British Rail' as it'd been known since 1965. Formed in 1948, when the Great Western, London Midland & Scottish, London & North Eastern and Southern Railways were taken into public ownership, by 1970 it had come of age; by 1970, it had modernised, downsized and dieselised, and many a report had been written on how the industry had been over-used and under-maintained during the war, as well as how much the subsequent service improvements, infrastructure upgrades and traction replacements had cost.

Pens had been filled and pencils sharpened the most when Dr Richard Beeching, a director of ICI, was brought in by the government to make the railways pay. His chairmanship was marked by the infamous *Reshaping of British Railways* (1963), which led to the closure of numerous loss-making lines and stations, a greater focus on the block movement of freight and the introduction of more modern management techniques. But though these policies would only contain BR's deficit, the sixties railway ended up considerably leaner than its fifties counterpart: in those two decades, route mileage had shrunk from 20,000 to less

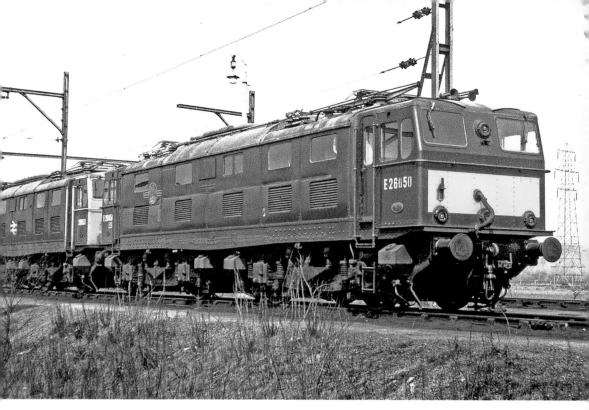

Above: E26050 was nearly nineteen years old when photographed at Wath in 1971. At this point, it had another decade to go before withdrawal. (Rail Photoprints)

Below: Less fortunate than E26050, Nos 26035 and 26042 were among the first EM1s to be taken out of traffic. Both await their fate at Reddish on 10 April 1971. (Rail Photoprints)

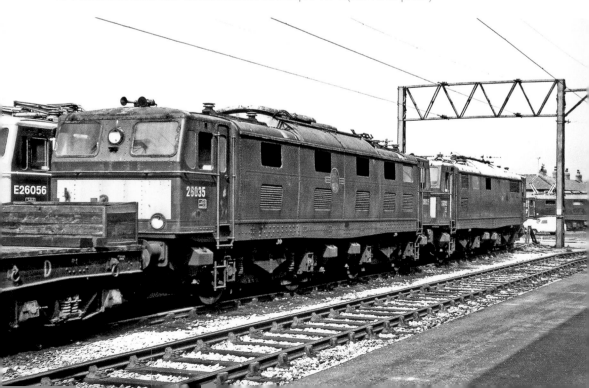

than 11,000, staff numbers had dropped from nearly 650,000 to 296,000 and the locomotive roster had fallen from more than 20,000 to just over 4,500.

In 1968, the pace of change was slowed by a new Transport Act, which sought to put the industry on a greater public service footing. This meant it not only wiped out BR's debt of £153 million, but also established Passenger Transport Executives (PTEs) in and around Greater Manchester, Glasgow, Merseyside, Tyneside and the West Midlands to aid the provision of local bus and rail services.

Where investment was concerned, of course, BR continued to need government approval for major projects like signalling or rolling stock renewal. Sometimes it was allowed to spend its own funds; sometimes it was allowed to borrow; always it had to justify itself by making economies, selling assets or seeking new revenue streams. Still, the seventies would see reports filed on the first non-supplementary air-conditioned services in Europe, electric services from Euston to Glasgow, 125 mph travel between London, the West and the North East, and the promise of even higher speeds to come. Against all this would be diatribes on delays, bad accidents, bad sandwiches, rising fares and crumbling levels of quality across the board.

The going wasn't going to be easy...

2

A Turn of Speed

The start of a new year; the start of a new decade. There's usually something positive to be said for both. And as Sir Henry Johnson – Bill – sat in his Marylebone office at the start of 1970, he knew he could allow himself a certain degree of optimism.

The booklet on his desk – not long unpacked from the printer's – was a palpable gem of its kind, and a sign of BR's intent to make good on the new Transport Act, which had wiped out its debt, ended the 'conflicts between social and commercial responsibility' and allowed the company to 'act as a thoroughly commercial, profit-centred enterprise'.

The world was moving on, and Bill knew that steam – and the image, the grime and the expense that went with it – had gone, continuous welded rail was making for smoother, quieter rides, electrification was progressing, and – in short – the past was becoming more of a foreign country every day. Sometimes... for Bill knew too that old signs and attitudes persisted in pockets up and down the country, many main lines were still controlled by semaphore signals and many loose-coupled goods trains still clattered over old-fashioned jointed track, much as they had for over a century.

Still, it wasn't as if the freight side hadn't been modernising: the 'merry-go-round'

The journey begins. The act of buying a ticket would start to change with the introduction of ticket machines around 1970. (British Rail)

Above left: Despite technological advances, traditional cardboard Edmondson tickets would survive in pockets until 1989. This one dates from July 1971 and took its purchaser from Portsmouth Harbour to Hilsea and back for 14 New Pence.
Above right: This booklet was published by BR to promote its hopes in light of the 1968 Transport Act (inter alia). (British Rail)

(MGR) network – whose trains carried coal from colliery to power station, loading and unloading automatically at low speed – was expanding such that by 1971 twelve power stations would be equipped with the loop lines, hoppers and discharge gear needed to facilitate this highly efficient mode of operation.

BR had also invested in the Freightliner concept, which featured large containers and long trains. There were seventeen dedicated terminals by 1968 and, though much of the initial traffic involved short-distance domestic hauls, the situation improved when it was found that rail was ideal for carrying containers to and from ports. Tilbury was duly added to the network in 1970, with Felixstowe and Southampton (Maritime) joining two years later. By the end of the decade, some 42 per cent of Freightliner's cartage would come from this source.

'Block trains' like these helped the railway get away from wagonload traffic – with all its in-transit transhipment and re-marshalling – to the comparative simplicity of trainload operation, a subject alluded to in British Transport Films' eleventh look at modernisation, which showed how such trains were allowing pulverised fuel ash to be transported from power stations to the clay pits of Peterborough, thus 'repairing' the scarred landscape by encouraging flora and fauna to flourish. Mind you, the film said closing the Somerset and Dorset line had let flora and fauna flourish too; and while shutting Widmerpool

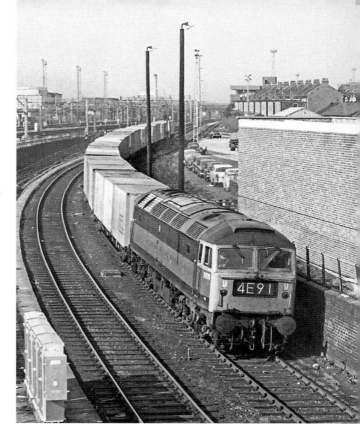

Right: In 1970, the port of Tilbury was added to the Freightliner network. Here, Class 47 D1776 works the 10.55 Willesden–Tilbury on 9 October that year. (Rail Photoprints)

Below: Gleaming 'Warship' D808 *Centaur* hauls the Wimbledon West Yard–Severn Tunnel Junction coal 'empties' past Pirbright Junction in 1970. The wagons had been collected from a number of household coal distribution depots. The locomotive would be withdrawn the following year as BR sought to rationalise its fleet. (Rail Photoprints)

might have stopped locals catching trains to anywhere, at least they could drown their sorrows in the old station building, where white-coated waiters served as many Mackesons, gins and bitter lemons as they could manage. Hurrah for the Schooner Inn!

The counterpoint, and the theme running throughout the film, was the super-efficient West Coast Main Line, the majesty of Euston and Coventry, and the high-speed trains connecting them. It was – as the film's title suggested – all about 'conserving the environment'; it was – in fact – all about rail being the answer to Britain's burgeoning road congestion problem, for though 1970 was European Conservation Year, it was also right in the middle of the rise in private vehicle ownership. From a health perspective, this was not good news; from a business one, BR had been worried when the number of cars on British roads exceeded three million, but this figure had nearly quadrupled, the rise seeing the railway's share of the total passenger market fall to just 8 per cent. There was also a growing threat from domestic airlines to contend with...

Market research had found that, with journey times of up to three hours, rail was the mode of choice and had the added advantage of delivering travellers close to shops and office blocks. Beyond three hours, people tended to let the plane take the strain. Electrification, though clearly a solution, was expensive, and while the £55 million project to raise the wires right through to Glasgow would be approved in February 1970, it was clear that – if rail were truly to compete with air – a new train would be needed.

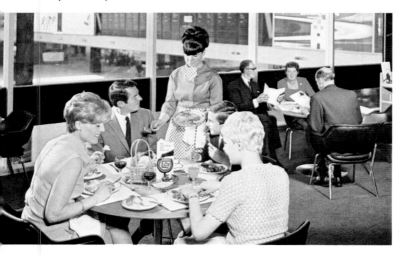

An image from *British Rail is Travelling... 1970*, showing the Lancastrian Grill at Euston, with its elegant views of the concourse and departures board. At the time, Euston's bars and cafés were proving so popular that they had to be extended. (British Rail)

25 kV AC Class 86 E3125 stands in June 1970 at Euston – the flagship station on BR's flagship West Coast Main Line. (Colour Rail)

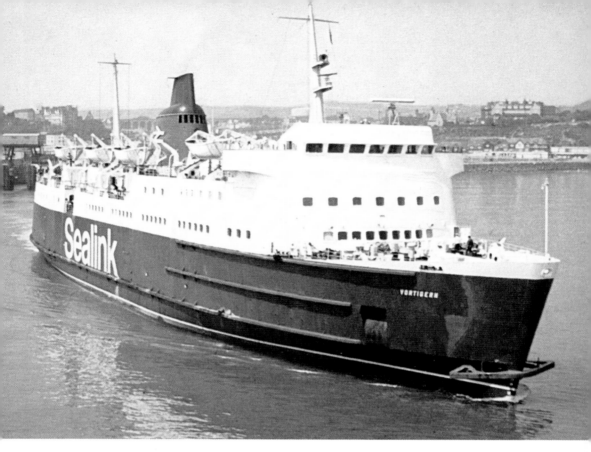

BR's Shipping & International Services Division was rebranded 'Sealink' in 1970. This postcard shows the 4,370-ton motor vessel *Vortigern*, which was launched in 1969 as the first of a new generation of multi-purpose ferries.

The seed of a solution had been sown in the Research Division's work on 'hunting' – an alarming lateral wheel oscillation that tended to affect rigid two-axle wagons running on rigid continuous welded rail, and which had been the cause of several derailments. BR's Director of Research, Dr Sydney Jones – latterly Technical Director of electrical engineers R. B. Pullin & Co. Ltd – came to believe it was similar to a dynamic instability suffered by aircraft known as 'flutter'. He duly set about recruiting a dynamicist from the aerospace industry. That man was Alan Wickens.

Wickens and his team – which included many more aerospace engineers – devised a new suspension system that could combat hunting and which, when applied to bogie vehicles, created a coach capable of 125 mph travel. There'd been an assumption that anything faster than this would need a total rethink in terms of track alignment and signalling; the famous Japanese 'bullet trains' were operating at speeds of up to 130 mph on relatively straight, purpose-built lines with gentle gradients, after all. Ever up for a challenge, the team wondered whether faster trains could be run on existing infrastructure. From their thinking, from their studies, came the Advanced Passenger Train (APT), which could get up to 155 mph, minimising passenger discomfort by tilting into curves. The project secured partial government funding in 1968 and clearance to construct a four-car experimental train, test track and laboratory the following year.

Did you know?

British Rail Engineering Limited – BREL – was incorporated on 31 October 1969 to maximise 'new opportunities' and 'integrate them with the primary duty of the railways', the 1968 Act having freed BR to use its spare workshop capacity to manufacture for outside industry. Formed in May 1970, it boasted a staff of 37,000 and an annual turnover of £100 million. Key workshops included Crewe, Derby, Doncaster and York. Crewe would go on to build the power cars for the prototype and production High Speed Trains.

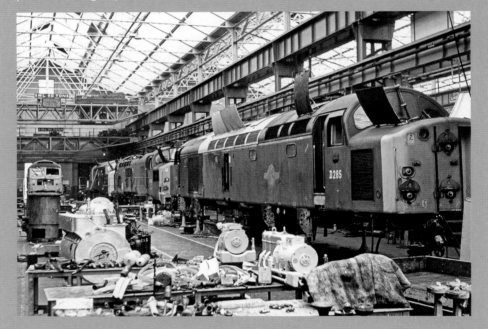

D285, D6892, and Nos 6876 and 1752 receive attention at BREL's Crewe Works. (Rail Photoprints)

Watching from the sidelines were the traditional railway engineers, many of whom were less than impressed with these aerospace 'upstarts'. They felt sure an alternative was possible, and by the end of 1968 had sketched out rough plans for a 'High Speed Diesel Train' (HSDT), which could reach the magic 125 and take full advantage of the new – 'Mark III' – coach design. BR's new Chief Engineer of Traction and Rolling Stock, Terry Miller, could see its potential and submitted a formal proposal to the Board in early 1969. Johnson saw the potential too and gave the project his public support, adding that, if the APT failed to prove itself within the next four to six years, the company would need something reliable to fall back on.

By the autumn of 1970, £800,000 had been granted for the development of a prototype. It was complete within two years, and featured Derby-built Mark IIIs bookended by Crewe-built 'power cars' equipped with 2,250 hp Paxman Valenta engines. The latter revved at around

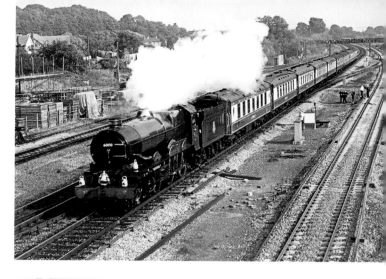

BR banned most preserved engines from January 1969. After much negotiation, steam returned in 1971, first in the form of ex-GWR 'King' No. 6000 *King George V,* which is seen here pounding past Magor that October. (Rail Photoprints)

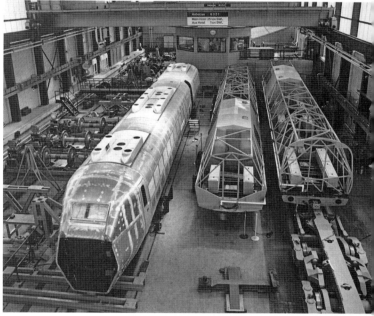

The experimental APT–APT–E under construction at Derby Works. There had been other tilting trains, but this was the first to feature an active mechanism, designed to respond automatically to lateral accelerations experienced by passengers. It made its first (reduced-speed) main line run in July 1972. (Colin J. Marsden)

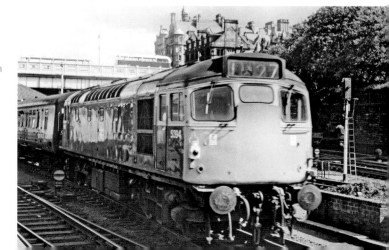

The operational benefits of using locomotives at both ends of a train were demonstrated on the Scottish Region, which introduced accelerated services between Edinburgh and Glasgow using (mainly) pairs of Class 27 diesel-electrics in May 1971. Here, No. 5394 is seen at Waverley in July 1972. (Rail Photoprints)

twice the rate of their contemporaries and were light enough to avoid track damage. Disc brakes were fitted to help the train stop from 125 mph in the same distance a loco-hauled one could stop from 100 on level track, while the twin power car arrangement – like the 'Blue Pullmans' of the decade before – dispensed with the need to run round at terminal stations.

With its sleek, clean lines and cyclops-like front end, the HSDT certainly looked the part as it sliced through the landscape. Yet through that single windscreen lay a problem, the lack of cabside windows and proper provision for a secondman being challenged by the unions, who argued that two fully qualified drivers should be present in all trains that travelled above 100 mph. As the APT-E had also been designed with 'single-manning' in mind, and as there was uncertainty about whether the extra responsibility for high-speed driving would be recognised financially, they refused to let their members work on either train until a settlement had been reached.

The APT team welcomed the 'blacking', as it let them rectify a number of faults. The HSDT team, however, had some work to do, though by the end of 1972 the power car interior had been adjusted and BR had agreed to double-manning with extra pay when speeds topped the ton. Trials began on the East Coast Main Line in January 1973, trials that soon saw the train live up to its name...

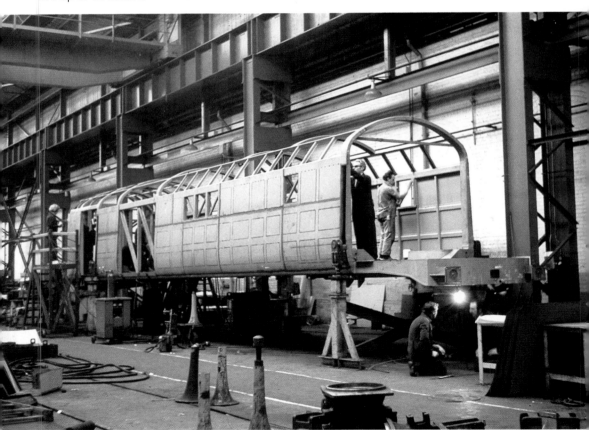

The HSDT taking shape at Crewe Works in 1972. (Colour-Rail)

3
Good Times, Bad Times

It's not often you can say you feel like Michael Caine, but today you do. A bit. You don't have your own theme tune, you aren't reading *Farewell My Lovely*, and you aren't due to throw anyone off the multi-storey car park at Gateshead, but as your train powers north from King's Cross to Newcastle you fancy yourself a touch closer to his cool, detached demeanour.

In fact, your train's better than Caine's – the opening scenes of *Get Carter* take place in an early Mark II, a carriage of mid-sixties vintage with compartments, pressure ventilation and wood panelling; you, though, are sitting in sealed splendour aboard a newer Mark IID, enjoying the benefits of air-conditioned travel – enjoying 'the highest possible standard of comfort on your journey', no less. You're not about to use the shaver point in the 'bright modern toilet', but the seating, the space and the 'Specrafloat' windows are a joy. Since the film's release in '71, services have sped up somewhat on the East Coast Main Line too, 1973's summer timetable seeing more 100 mph running, thanks largely to track realignment and resignalling through Peterborough, which did away with the old reverse curves, and which helped bring the 'Flying Scotsman' down to a 'fastest-ever' journey time of five and a half hours...

Impressive, but not as impressive today, perhaps, as the thought of luncheon. The steward will be along in a minute, and you're just imagining what you might imbibe before the call to the restaurant car comes. A Double Diamond would work wonders, but as you muse on the prospect of gammon steak or grilled sirloin, your reverie is disturbed by a strange double-ended beast that rockets by, its livery the reverse of the usual Inter-City blue and grey.

'Deltic' No. 9001 *St Paddy* climbs away from Gasworks Tunnel, near King's Cross, in 1973. The leading coach is an air-conditioned Mark IID, which featured 'Spectrafloat' tinted windows, and which entered service between London and Newcastle on 12 July 1971. (Rail Photoprints)

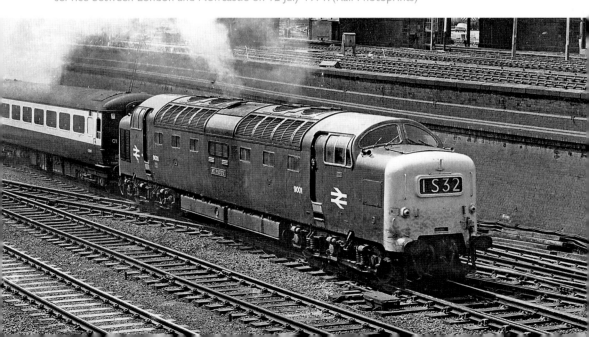

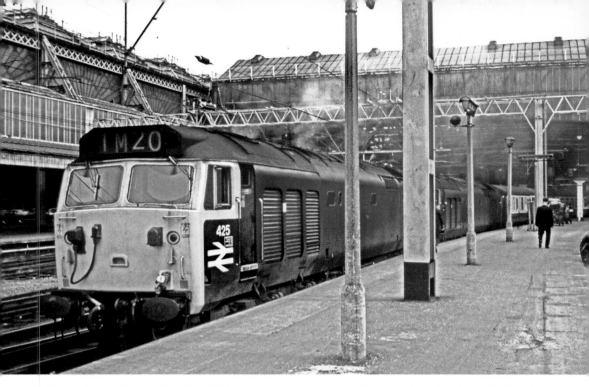

Above: A pair of Class 50s (No. 425 leading) prepares to leave Glasgow Central with the Up 'Royal Scot' in 1973. Electrification would see the locomotives moved to the Western Region within three years. (Rail Photoprints)

Below left: The autumn 1973 issue of BR's *Travelling* magazine, featuring the record-breaking HSDT on the cover and the tempting prospect of recreating 'Fashion's Layered Look' within.

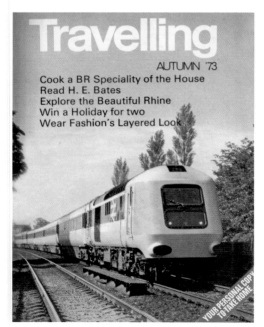

'What on earth was that?' you ask, as the steward appears. 'That sir,' he smiles, 'is the High Speed Train. They're running some tests today. Extraordinary isn't she?' She is, and you later learn that you'd witnessed the last in a line of record-breaking runs: on 6 June, the HSDT had matched the world diesel traction record of 133 mph set by Germany in 1939. On the 11th, it reached 141 near York on a run so smooth you could have written a letter or rolled a cigarette. The next day – the day you saw it – it powered its way to an impressive 143.2 over the quarter-mile between Northallerton and Thirsk.

Further high-speed runs would come to the former LNER in the years ahead, but the following month would see the next stage in the electrification of its erstwhile rival, the West Coast Main Line. A six-hour service

between Euston and Glasgow had come in 1970, when pairs of powerful Class 50 diesel-electrics began to ply the punishing gradients of Shap (1 in 75) and Beattock (1 in 67), north of Crewe. Three years on and the marching masts allowed the changeover from electric traction to come now at Preston, where trains were held up anyway, as Anglo-Scottish services lost or gained carriages to or from Blackpool, Barrow and Carlisle. Killing two birds with one stone like this allowed the northbound 'Royal Scot' to be accelerated by thirty-eight minutes, and a six-hour timing to be restored to its southbound counterpart. Indeed, four daily trains in each direction were now working between Euston and Preston 'in less than three hours'.

This last revelation came in *Travelling*, BR's on-board magazine, the autumn issue of which also celebrated the opening of a new station at Stevenage, trials of 'PEP'– a new third-rail electric multiple unit for the Southern Region – and the HSDT's recent triumph. Leafing through these colourful pages on a rainy October day as you pulled in to Cardiff, Swindon or Reading, you might have overlooked the H. E. Bates short story and tempting men's fashions to feel just a touch hard done by. In fact, high-speed travel would be heading your way soon, but for now innovation must take the form of Bristol Parkway – a new type of station, built near the intersection of the M4 and M5 motorways, with parking spaces for 600 cars.

The idea was to give motorists the advantages of an inter-city station without the hassle of city centre parking and congestion. It was an immediate success, local residents soon realising that it was much more relaxing to reach London or the north by driving to Parkway for a direct train than battling their way to the middle of Bristol to get one from Temple Meads.

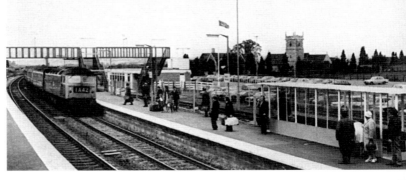

Bristol Parkway around 1972. The 'Parkway' concept had been tested at New Pudsey in the late 1960s. Similar stations at Birmingham International (1976) and Southampton (1986) would follow. (British Rail)

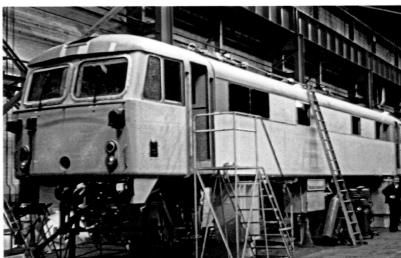

Vanquishers of the Class 50s – at least as far as Anglo-Scottish services were concerned – were the 5,000hp Class 87 electrics. Here, No. 87001 comes together at Crewe in 1973. (Rail Photoprints)

The station had been opened by former Transport Minister Richard Marsh the previous May in one of his earliest public acts since taking over from Johnson in September 1971. At forty-three, the charismatic, sideburn-sporting Marsh was a self-professed motorist, but one whose father had worked for the Great Western at Swindon. In office, he promoted the export of BR technology, proved to be a good spokesman and came with an awareness of the problems that further cost increases could create. The latter was probably just as well, for while the latest Act had brought financial stability, the subsidies provided to fund loss-making, socially valuable lines were falling every year. Furthermore, the contemptuous attitude to railways now evident in Whitehall was starting to be shared by the car-owning classes, for whom train travel was something their parents had done in the days of steam. Even the enthusiast press was blaming management for the mess its beloved industry was in – not least *The Railway Magazine*, whose August 1973 edition recalled that 'PEP' had first come to light as long ago as January 1967, the HSDT was running 'at least twelve months behind schedule', while the APT programme seemed 'to be going backwards'.

Did you know?

The project to complete the electrification of the West Coast route to Glasgow from Weaver Junction (where the Liverpool line diverges) had been approved in February 1970. It would eventually involve the erection of over 15,000 steel masts and the suspension of some 1,650 miles of wire. Bridges would be raised to aid overhead equipment clearance, while a combination of continuous welded rail and more track realignments would allow speeds to be raised too. The route's semaphore signals – not conducive to fast running – would also be replaced by multi-aspect colour lights controlled from new signal boxes, those at Preston and Carlisle having opened during 1973, Warrington having opened the year before that.

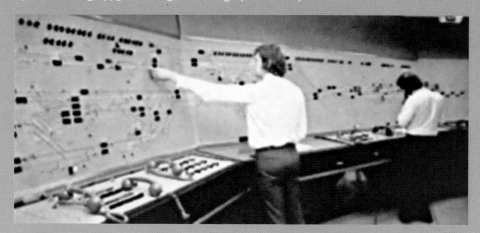

The new 'power signal box' at Carlisle, which opened in 1973, and which controlled multi-aspect colour light signals, whose consistent spacing allowed more trains to run on a given line. With them came BR's Automatic Warning System (AWS), which alerted drivers to 'distant' signals, using magnets in the track and receivers on locomotives. (British Rail)

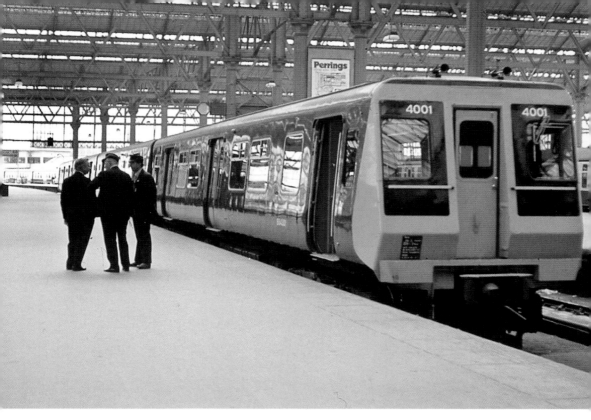

The HSDT and APT were not the only prototype designs produced in the early 1970s. Seen at Waterloo in 1973 is No. 4001, one of the experimental 'PEP' electric multiple units, which featured sliding doors and led to BR's 'second generation' fleet, comprising Classes 313, 314, 315, 507 and 508. (Colour-Rail)

Like the HSDT, the APT-E had suffered from union opposition. Unlike the HSDT, it – or rather its gas turbine engines – had suffered from the oil embargo imposed by the Organization of Petroleum Exporting Countries in response to the USA's support of Israel during that year's Arab–Israeli war. This led to fuel shortages and widespread price rises, forcing British Leyland to cancel its automotive turbine programme and BR to consider electric traction for the production version.

For Marsh, it was clear that running BR was a complicated business that was doubtless easier for the nation's '27 million railway experts' than the '190,000 of us who earn our living on the railways'. Still, the media wasn't as irksome as the government, which he believed to be selling the railway short. 'In terms of capital investment for renewal, research, development and improvement,' he wrote in the Board's 1972 Annual Report, 'the railways' share has not been comparable with the millions poured into other forms of transport.' New motorways and trunk roads, he went on, 'represent a national investment every year more than five times greater than investment in British Rail, and even then most of the railway investment is to keep the system going'.

With ministers asking questions about the viability – and size – of the network, Marsh pointed out that analysis showed there to be *no* viable network size and urged the government to accept that 'the social benefit to the community as a whole by keeping it intact was far greater than the book-keeping loss'. Yet he was fighting a losing battle, as rising inflation was turning any chance for investment into a call for cuts.

Did you know?

The early '70s would see the withdrawal of several luxury Pullman services. The celebrated 'Golden Arrow' and 'Brighton Belle' were removed from the timetable in 1972, the latter's last run enjoying the patronage of actress Dame Flora Robson and Led Zeppelin manager Peter Grant, among others.

Next to go would be the 'Blue Pullmans'. Delivered to BR in 1959 and put into service on the Western and London Midland Regions over the next two years, these trains – though beautiful – were also prone to poor riding at speed. By 1972, development of the First Class accommodation in BR's Mark II carriages had also made the supplemental fare for their services seem over-priced and irrelevant. The units were duly withdrawn, with the final timetabled train running on 4 May 1973.

The empty stock of the last 'Blue Pullman' run to Bristol leaves Temple Meads on 4 May 1973. (Rail Photoprints)

As 1973 threatened to become 1974, Marsh could look back on a real curate's egg of a year, that same Annual Report revealing a deficit of £26.2 million, a fall in passenger miles of 6.3 per cent and a drop in freight tons carried of 4.7 per cent. At the same time, technology really was increasing speeds, increasing efficiency and improving safety. Not that there was any room for complacency, as the events of 19 December would prove...

The story began at Paddington, where the 17.18 for Oxford was preparing to leave. The locomotive – D1007 *Western Talisman* – had 'hooked on' at quarter-past and its driver now waited for the off as the engines hummed behind him. On board, passengers opened their *Evening Standards*, their novels, their packets of crisps; a few wished they'd bought coffee before boarding this buffet-less train.

The signal cleared, the 'right away' received, *Talisman* revved up and the thirty-odd passengers standing in the corridors steadied themselves as the train snaked over the points and onto plain line. The speed soon climbed to 70 mph, as Ladbroke Grove, Old Oak Common and Acton flashed by. But for a lurch on the approach to Ealing Broadway, all was well. 'Must have been a bad rail joint,' the driver thought. He was wrong... As they neared West Ealing, *Talisman* hit the facing point machine at Longfield Avenue Junction and bounced up and over, its bodyside scraping along the rails with a sickening metallic scream. The leading coach remained upright and locked to the locomotive, but the next five jack-knifed and derailed foul of the next line.

'I was just standing there,' one passenger later told the press. 'The train seemed to start to brake... it started to judder and all of a sudden I could see the rails flying past the windows.' As her carriage began to sway, the 'lights went off and everybody was ... thrown all over the place.' With them went the *Standards*, the novels, the snacks. In the tumult, ten people were killed and ninety-four people were injured.

Marsh was soon on the scene. West Ealing was and would remain the worst accident of his tenure. At first, there was speculation that an electrical fault may have made the points move beneath the train, but evidence on the ground revealed a telling trail: at Old Oak Common, a 'limit of shunt' board had been dealt a heavy blow, at Acton several cable brackets had been broken off, at Ealing Broadway platform coping stones had been dislodged.

On 19 December 1973, an incorrectly secured battery box door on D1007 *Western Talisman* opened and struck point machinery at Longfield Avenue Junction, near West Ealing. The resulting derailment led to the loss of ten lives. (STEAM Museum)

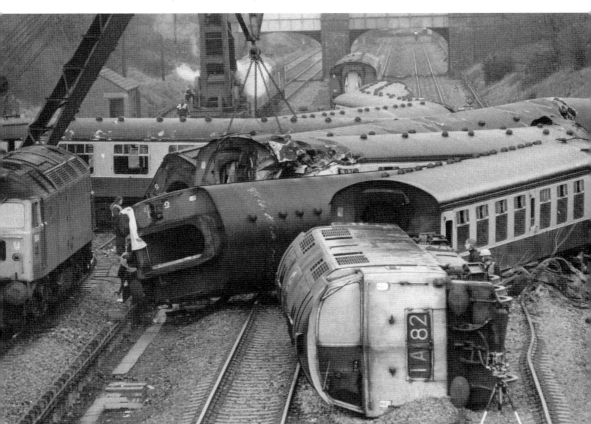

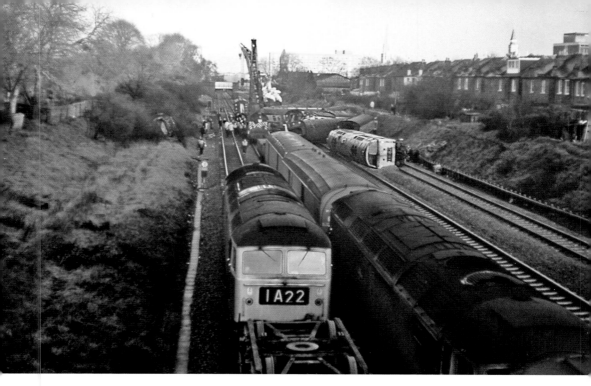

Western Talisman remains on her side post-derailment while Class 47s attend with cranes and breakdown trains. (Colour-Rail)

A look at the locomotive soon found the cause: at some point after departure, one of its battery box doors had dropped to the horizontal position and was held there by stays. This let it hit the board, but as it struck the coping stones, the stays were torn away. The door then fell further and struck the rodding between the point motor and switch blade at Longfield Avenue with such force that the rods were bent, the blades moved and the train came off.

This much was clear, but behind it all lay a safety catch that wasn't safe...

As originally designed, these 'pear-drop' fittings couldn't be fastened and relied on gravity to hold the battery box doors shut. However, there had been a number of occasions when they'd failed, so Laira Depot modified them such that they could be screwed down. Alas, no one realised that what could be used to hold a catch down could also be used to hold it up, out of the way. Had the modification been submitted to scrutiny further up the chain, someone might have spotted the risks to others and ironed them out before implementation. As it was, Laira pressed ahead and it became part of a fitter's normal routine to secure the catch in the raised position, so that it didn't interfere with the opening of the doors when charging or changing batteries. When *Talisman* was prepared at Old Oak on the 19th, someone – the official investigation never established who – neither locked the battery box door nor secured the catch in the lowered position again.

It was a simple mistake, but a fatal one, and a simple reminder that change could bring new challenges – and new dangers.

4
Wires Over the Border

Laying on the living room floor in after-Christmas glow, Peter reaches for the controller and turns the knob. From the other side of the oval – big enough now to surround him – comes D5572, hauling a rake of wagons slightly longer than when his 'Freightmaster' set was new. If only he were Hornby-size! Still, the green '31' looks fabulous, and he's just admiring the blue 'Fine Fish' van as it passes when the train stops, the lights go out and the fire goes with it. Another power cut. *Mu-u-um!*

The blackouts came when they felt like it – or so it seemed. Peter might not have understood why, but Mum and Dad did: the government had tried to beat inflation by capping wage increases, but this brought conflict with the unions – especially the National Union of Mineworkers, which was pushing for a pay rise in line with the cost of living. When negotiations failed, their overtime ban became a strike, which caused coal stocks to dwindle just as the Arab–Israeli war was driving up oil prices. Imports were impossible and electricity consumption had to be reduced, so Prime Minister Edward Heath imposed a three-day working week from midnight on 31 December 1973. News bulletins were filled with images of candle-lit shopping, picket lines and plucky pensioners. Petrol was rationed, a speed

West Coast Main Line electrification under way via a 'wiring train', made up of converted carriages. This image is taken from *Electric All the Way*, a special booklet BR produced to mark the start of full electric services between Euston and Glasgow from 6 May 1974. (British Rail)

limit was imposed and football matches switched from evenings to afternoons to avoid the floodlight ban. It couldn't last. It couldn't go on. Heath called a General Election on 28 February. He asked: 'Who governs Britain?' The public decided 'not you'. Harold Wilson's new Labour government went on to grant the miners a pay increase that would see an end to the strike and ensure that the next time electricity appeared in the news, it would be for a rather more positive reason.

So to May. So to the 6th. So to the official launch of electric services over the

Another *Electric All the Way* image, this time showing the men who made electrification happen and the short-wave radios teams used to maintain contact. (British Rail)

Did you know?

The electrification of the northern section of the West Coast Main Line created a need for electric locomotives powerful enough to deal with the punishing gradients of Shap and Beattock (inter alia). BREL's Crewe Works duly built thirty-six 5,000 hp 'Class 87s', which featured GEC electrical equipment and were capable of 110 mph. The first – No. 87 001 – was introduced in June 1973; No. 87 035 appeared in October 1974, but the final locomotive entered traffic as No. 87 101, being a test bed for new electronic power control equipment. After spending many months on trial, it entered regular service in 1976.

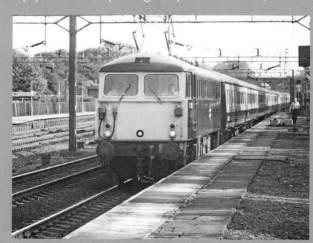

Diesel and electric locomotives were reclassified in 1968, with renumbering following from around 1973, as one-, two-, three- and four-digit numbers became five-digit ones. Class 87s like No. 87026, seen here in 1974, were the first to receive the five digits from new. The train features Mark IID air-conditioned stock; Mark IIIs would be introduced to the West Coast Main Line from 15 December 1975. (Colour-Rail)

401-mile route between Euston and Glasgow. It was the culmination of endless planning, of endless toil through harsh winters and blistering summers, of men standing atop special trains that moved slowly through the barren border counties landscape, of the old yielding mile by mile to the new.

The well-known railway author O. S. Nock would call it 'one of the greatest milestones in the long history of British passenger train services'; it was certainly a far cry from the pessimism of the previous decade's Beeching Report, which had feared that 'the erosion of daytime rail traffic between London and Scotland would probably continue to the point where some trains would have to be withdrawn'. Now, six out of eight daily trains were re-timed from almost six hours to a shade over five, while the famous 'Royal Scot' was rescheduled to run between Euston and Glasgow Central in five hours exactly at an average speed of over 80

Right: Richard Marsh, BR Chairman 1971–76. (British Rail)
Below: In 1974, the Labour government reprieved six lines due for closure. One such was the Inverness–Kyle of Lochalsh route. In this view, Class 26 No. 5339 arrives at Dingwall with an Inverness–Kyle service that same year. (Rail Photoprints)

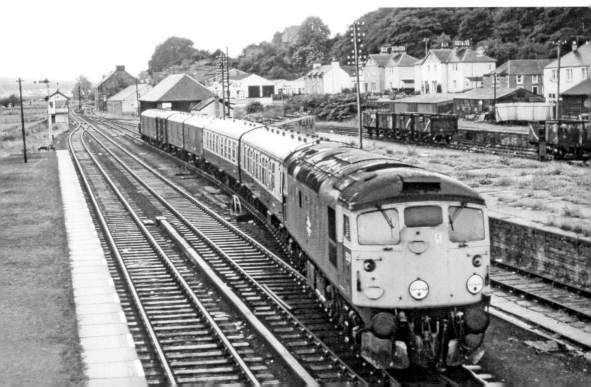

mph. And though the three-day week had delayed carriage production such that only three sets of air-conditioned Mark IIDs were ready for the start of service, passenger numbers still climbed by 40 per cent over the coming months.

There was more good news when that year's Railways Act reduced BR's capital debt from £438.7 million to £250 million and replaced the individual payments for passenger services brought in by the 1968 Act with one 'Public Service Obligation' grant. In part due to a post-oil crisis need to cut the public's dependency on motoring, the government also reprieved six lines previously earmarked for withdrawal, thus allowing passengers to travel still from Bedford to Bletchley, Stockport to Stalybridge, Ashford to Hastings, Wimbledon to West Croydon. The Cambrian Coast line to Pwllheli lived on too, as did the branch to Kyle of Lochalsh so beloved by backpackers and enthusiasts, the latter warming in particular to its combination of older stock, growling Type 2s and the spectacular scenery on the way up to Skye.

Yet the 1974 Act wasn't all about passenger services, for if Whitehall considered it to be 'in the interest of any locality, or of some or all of its inhabitants' for freight facilities 'to be provided in that locality or elsewhere', a 'Section 8' grant could be made for the provision of private sidings, rail-access roads and handling equipment. The first company to take up the offer was Containerbase of Liverpool, which put the money towards re-equipping its Aintree railhead. Elsewhere, Lever Bros invested in a new road-rail warehouse at Port Sunlight, while Redland Aggregates erected a 1½-mile conveyor belt to carry crushed limestone from Buddon Wood in Leicestershire to a new yard at Barrow-on-Soar.

Did you know?

In a bid to improve the riding quality of rolling stock – wagons in particular – BR's Research Division developed a High Speed Freight Vehicle to demonstrate its work into wheel-rail dynamics. The first variant – HSFV-1 – was built in 1966. Within two years, HSFV-4, a converted ferry van, would prove the practicality of running long-wheelbase two-axle wagons at speeds of up to 75 mph. The first (air-braked) wagons of this type started to appear in 1969 and went on to feature in the Air Braked Network, whose overnight trains were essentially sets of mini block workings, coupled together for the common part of their journey. This reduced re-marshalling and increased the chance of a 'next day delivery' for customers like Fisons, a fertilizer manufacturer based near Bristol.

Another aggregates business – Tilcon – was among the growing number investing (and being encouraged to invest) in their own wagons. BR's punning publicity referred to the '80 leading companies' that had taken an interest in 'private collections', not that these were anything like the short-wheelbase, five- or seven-plank wagons that had made up the 'private owner' fleet in days gone by. No, they were modern, sleek, air-braked vehicles that could be run at speeds of up to 75 mph. And they weren't alone, BR's own fleet earning increasing revenue as the 'Air-Braked Network' (ABN) slowly spread.

The launch of the Bristol–Glasgow service in October 1972 hadn't been an immediate success, but when Glasgow–Harwich was added a year later, the distribution possibilities started to become more apparent, the ferry between the latter and Zeebrugge providing a

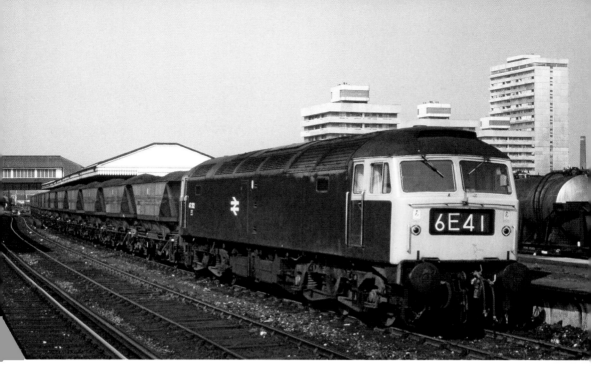

Above: Class 47 No. 47202 takes charge of a loaded 'merry-go-round' service in 1974. At the power station, the train will be emptied automatically while running at ½ mph – a system that improved the efficiency of BR's coal operations no end.

Below: The hoppers being hauled by this Class 31 are 'unfitted', meaning that they have no continuous brake capacity. On trains like these the guard will keep a hand on the brake handle in his van to make sure the couplings remain taut and don't snap. A few unfitted freights clanked on until 1983, traditional coal and scrap flows lingering longest. (Colour-Rail)

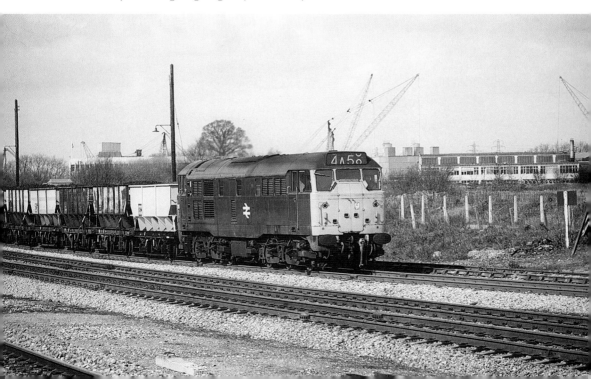

key link to continental Europe. By the mid-'70s, most of the country had been covered, with trains running from South Wales to Warrington, Birmingham to Tyneside, Dover to Dundee, Leeds acting as a major hub for both Tyneside and Humberside.

Did you know?

BR's Red Star express parcels started trading in 1963, and was carrying five million parcels a year by the end of 1979. Profitable in the 1980s, it became a separate division in 1988, though hopes for an increase in business via the Channel Tunnel were dashed by recession in the early 1990s.

Add to this BR's extension of its own 'Red Star' parcels business, a new link joining 147 Southern Region stations to twenty-one centres in the Midlands, North West and Scotland, and it was clear that a new traffic management system was badly needed. Both the Western and Eastern Regions had experimented with various techniques in the past, but the best answer had been found in America, where the Southern Pacific Railroad had developed a Total Operations Processing System, which used computers to monitor the position and use of rolling stock across an entire organisation. The Board had committed to £10 million of investment for 'TOPS' back in 1971. When first rolled out in the West Country, some wags suggested that – if it didn't work – it would be Back Onto Tried and Tested Old Manual

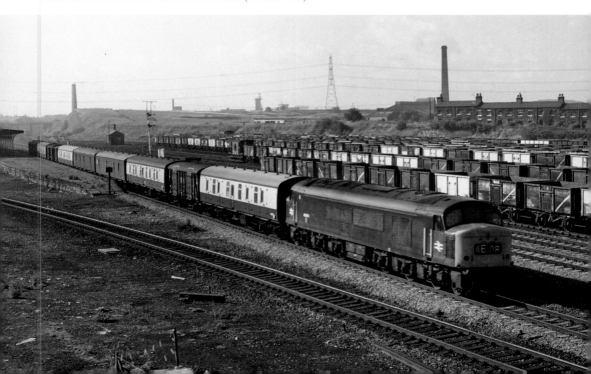

A Class 46 on a 'parcels' in 1975, by which time Post Office traffic had dropped from its peak. Cutbacks had started in 1968, when the PO introduced a two-tier system of delivery and decided there was no need for slower second-class mail to be carried by train. From 1974, it would choose a combination of road and rail in a bid to cut costs further. (Colour-Rail)

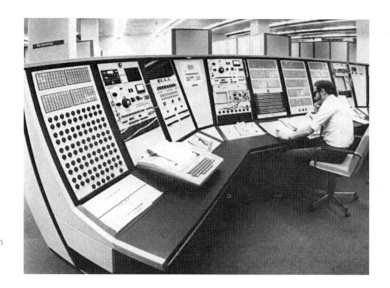

An official BR photograph
of one of its TOPS
computer centres.

Systems, but as *The Railway Magazine* noted, there was no need for BOTTOMS when TOPS remained 'tops'.

And so it did, the pace other areas came 'on-line' allowing Dr John Gilbert – Minister for Transport Industries – to press a button in the Board Room at 222 Marylebone Road on 27 October 1975 that 'cut-over' the last one, in North East England. From 11.00 that day, BR's computers were fully linked to 155 centres across the 11,500-mile network, and

The APT-E was powered by a gas turbine, which like electric traction could deliver twice as much power as diesel, but unlike electric traction would not confine test runs to electrified areas. Here, the train nears Steventon on 3 August 1975, the day it would break the 150 mph barrier. (Colour-Rail)

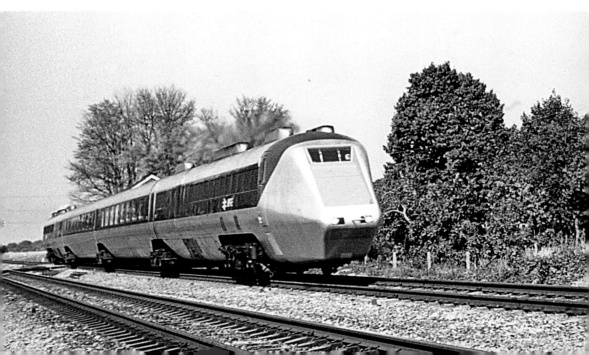

fully able to provide minute-by-minute information on the whereabouts and status of every wagon – and there were certainly a lot, with well over 300,000 vehicles of varying size and description being listed. But just as TOPS had produced economies in locomotive use and allowed more effective crew rosters to be created, now it could show that some 20,000 wagons could be withdrawn and that some £3 million in capital and maintenance costs could be saved.

The world was getting slicker. The world was getting smaller. The world was getting faster. Soon it would get faster still, what with the first production batch of HSTs destined to transform Western Region services out of Paddington. With twenty-seven trains under construction, the prototype was transferred to Old Oak Common for staff training. It entered service on 5 May 1975, working existing 100 mph schedules. BR's catering division – by now re-branded Travellers-Fare – devised a special 'high-speed' menu, which included draught beer for the first time. Many passengers enjoyed a pint of Whitbread (32p) – or a cup of tea (8p), or fruit pie (16p); many more marvelled at the effortless speed, the comfortable seats, the airiness and the automatic vestibule doors. In fact, the train proved so popular that some altered their travel plans just to ride on it.

In comparison, the APT-E was little more than a laboratory on rails at this stage, though even greater speeds would come once it too had migrated westward: at 05.00 on 27 July, it set off from Uffington and soon clocked up 130.9 mph; the 150 mph barrier was broken on

Among the many steam engines that formed the Shildon cavalcade in August 1975 was No. 709 *Hardwicke*, a London & North Western Railway 'Precedent' built in 1892. Soon it would take its place at the National Railway Museum, which opened in York that October to coincide with the 'RAIL 150' celebrations. (Rail Photoprints)

3 August, but the best came a week later when the train sliced through Didcot to reach a record-breaking 152.3 mph.

August was to be a month of celebrations, a month of contrasts, for what started with the new ended with the old, a cavalcade at Shildon marking the 150th anniversary of the Stockton & Darlington Railway. The promise of steam ensured a crowd. The promise of steam was kept by a truly impressive display of British locomotive technology: leading the pack was a replica of *Locomotion*, following on were *Hardwicke*, *Flying Scotsman*, *Raveningham Hall*, *Sir Nigel Gresley* – names as famous perhaps as 'Thomas', 'Percy', 'Gordon' or 'James'. Yet, the last of the line – *Evening Star* – was not allowed to shine brightest, the final place in the procession going to the HSDT, which purred through to denote 'the start of yet another chapter in this long history of locomotion'.

Such pride in the industry, pride in the job. But what next?

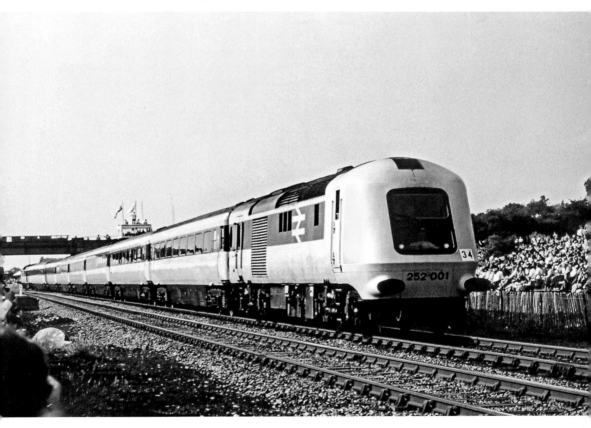

Bringing up the rear of the Shildon cavalcade was the HSDT, which pointed to the future, but whose slightly grimy appearance attracted ill favour in the railway press. (Rail Photoprints)

5
The Finishing Line

'I don't know what's the matter with children these days.' The old man puffs from behind the paper and his wife nods in agreement. Hooligans had gouged holes in the Centre Court at Wimbledon, sprayed paint on surrounding buildings and defaced a clock opposite the royal box. Vandalism – an ugly word, a frightening word to the elderly and infirm – was in the headlines again. It seemed to be on the up, and the railway was by no means immune.

Solutions were hard to find, though the Scottish Region had started using a locomotive to 'patrol' lines in the Glasgow area. If attacked, police on board radioed colleagues, who would apprehend the perpetrators in unmarked cars. Well over 200 arrests had been made by this means, but the battle was also fought in the mind, BR commissioning a film to combat the stone-throwers, the intruders and obstruction placers. The finished result – *The Finishing Line* – would be at once controversial and provocative in its depiction of an imagined school sports day, where each event involves trespass, damage, injury or death. In one scene, children are felled by passing trains as they cross the line in teams, in another passengers and driver are badly hurt by colour-coded stones thrown for points. The blood looked real, the distress palpable...

Yet not all children wanted to destroy. Some still marvelled at the railway scene. Some still stood on station platforms, flared jeans flapping, parkas slapping, notebook and pencil held tightly in hand. Those who did in early '76 might have copped the production High Speed Train, inheritor of the record-breaking prototype, since redubbed the 'Inter-City 125' to reflect its nominal top speed, which the doyen – No. 253 001 – had reached during a commissioning

In a bid to tackle vandalism, the Scottish Region had started 'patrolling' lines in the Glasgow area. Here, two Class 303s are seen at Neilston High in March 1976. (Colour-Rail)

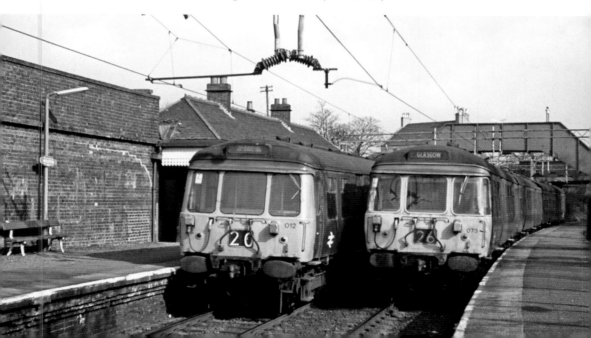

run between Derby and Morpeth on 5 March. The following month would see it transferred to the Western for driver training, which increased as more sets came 'off works'.

Like their prototype counterparts, the production coaches had been built at Derby's Litchurch Lane Works, the power cars constructed at Crewe. Unlike their prototype counterparts, however, the latter were to look quite different, a wider windscreen giving good forward-facing views to both driver and secondman as they sat side by side in a cab newly fashioned by industrial designer Kenneth Grange. This – along with a striking new livery – gave the train an imposing, purposeful appearance.

Did you know?

From March 1976 – after the opening of the country's 'largest operating blast furnace' at British Steel's Llanwern plant near Newport – block trains were used to bring in iron ore from the terminal at Port Talbot, some 46 miles away. Rakes of up to twenty-seven 100-ton bogie wagons ran at 60 mph, in order to keep the route as clear as possible for the Inter-City traffic that shared it. Initially, 'Britain's heaviest freight trains' were hauled by three Class 37s. The wagons were loaded automatically three at a time from bunkers at the port, and were discharged individually by being rotated (without uncoupling) at Llanwern. This part of the operation remained, but the '37s' would be replaced by pairs of Class 56s from July 1979 (see page 39).

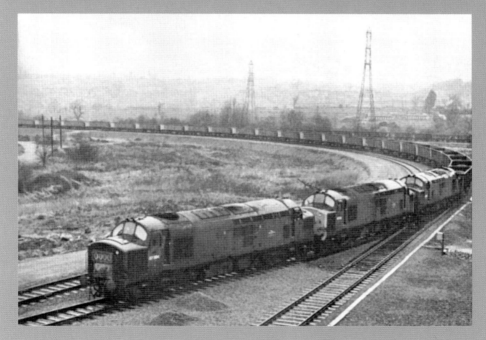

This image of a triple-headed iron ore train featured in an official Western Region publication. Note that the leading Class 37 has its headcode blinds wound to '0000'; four-character headcode displays were discontinued from 1 January 1976. (British Rail)

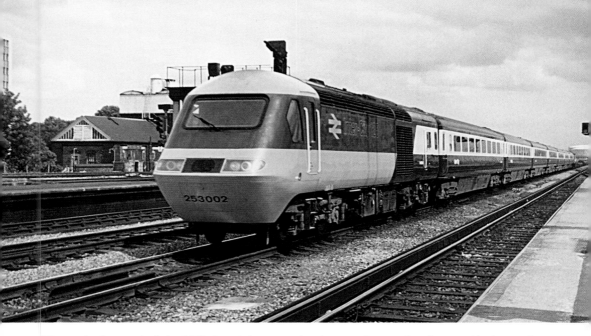

BR was justly proud of the HST, though it was a pity that guards were less happy with the small compartment they were given at the rear of each power car. Better accommodation would eventually be provided in a new design of coach. (Colour-Rail)

Though some HSTs entered 100 mph service that August, from 4 October all the design and development work, the track and signalling upgrades, the training and train planning came together with the launch of the 125 mph timetable and a world where Bristol was a mere seventy minutes from London, and where passengers could enjoy a 'Great British Breakfast' as their train terrified rabbits from their line-side resting place.

The public's imagination was caught almost immediately: henceforth, children who dreamt of driving trains fancied themselves at the controls of a '125', while all manner of memorabilia, advertisements and imagery meant they fast became synonymous with British Rail, a company that itself had a new face – the face of Peter Parker.

Having become disillusioned with both Labour and Conservative governments, who failed to see that long-term planning and clearly defined objectives were essential for BR, Marsh had decided not to request his statutory five-year appointment be extended. He'd also been disappointed that the latest Act, while offering grants for businesses to set up rail facilities, had made no mention of socially necessary freight services, and had simply tired of the task of running trains. By his own admission, his heart had been darkened too by the death of his wife in a car crash the year before. It was a tragic end to an uneasy tenure, Marsh – or Sir Richard as he now was – having overseen steam's return to the main line, the development of high-speed

Did you know?

To maximise high-speed running on the Western Region, some signals were re-spaced, and a three-year programme of track realignments was undertaken at seven sites between Acton, Box Tunnel and Bristol Parkway. Ballast was also renewed to improve stability and the last few remaining lengths of jointed track were replaced by continuous welded rail.

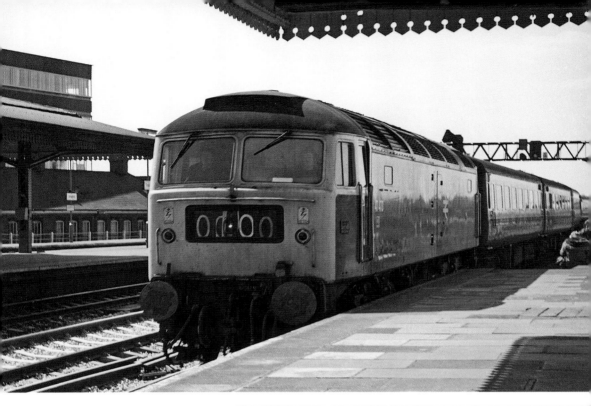

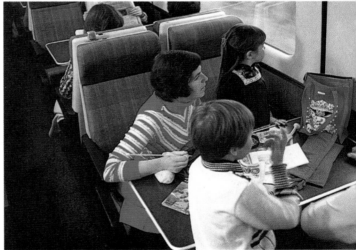

Above: Of the planned
161 complete HST sets,
only ninety-five would be
authorised by Whitehall. This
meant loco-hauled formations
– like this one headed by
No. 47473 – would still be used
on certain secondary duties.
(Rail Photoprints)
Right: A young family enjoys the
delights of Second Class, HST
style. Note that the commodious
table does not align with the
window – a problem not suffered
by First Class passengers.
(British Rail)

travel and the introduction of TOPS, while suffering strikes, three-day weeks, soaring oil prices, galloping inflation and falling passenger numbers as fares doubled to keep up with costs.

Parker's appointment had been announced in March; he became a part-time Board member the following month and took over that September. A great enthusiast and motivator, he was as keen on the HST as the drivers quick to join the unofficial '140 Club' (until speed governors were installed to cut off the power at 128 mph), and the small boys who shuddered with fear-excitement as these whining, shining, double-ended beasts sped past them.

Left: A badge produced by BR in the late 1970s to celebrate the excitement of travelling by HST (or 'Inter-City 125', as the trains were also known).
Below: Peter Parker (right), BR Chairman 1976–83, meets the management at BREL's Swindon Works. He was knighted in 1978. (STEAM Museum)

Imagine taking a journey from Cardiff to London on this train of opportunity. From a cold platform, you step into the elegant Mark III's bright yellow vestibule. The saloon door swishes open like the Starship *Enterprise* and you head for a Second Class seat that's in line with the window. You settle and sit back in the blue tartan, contemplating what delights the buffet might offer. The speed soon climbs and you look around as pipes are puffed, coffee is drunk and crosswords are completed. Everyone is happy, everyone content. Well, perhaps not quite everyone...

Did you know?

The 3,250 hp Class 56s came about after the 1973 oil crisis had opened government eyes to the need for more coal. This meant more trains – and more freight locomotives. Brush won the contract, but – lacking workshop capacity – subcontracted to Electroputere in Romania. The first '56' was delivered in August 1976 and would be followed by twenty-nine more, although manufacturing faults led BR to hold off acceptance and eventually bring the project 'in house'. Early arrivals were based at Tinsley Depot to work 'MGR' trains, though aside from their South Wales exploits (see page 35), they could also be seen on Freightliner traffic up and down the country. By 1984, there would be 135 on BR's books.

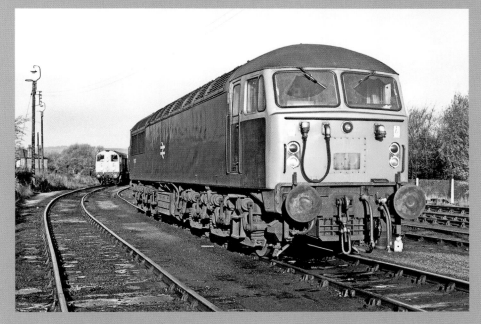

One of the original 'Romanian' Class 56 diesel-electrics, No. 56002 is seen at Barrow Hill Depot with Class 20 No. 20034. (Rail Photoprints)

One lad – a little older, a little wiser perhaps – stands in the vestibule with the droplight down. His flares are still, his lank hair stilled by grease, his parka hood ruffles in the slipstream. The cold plastic 'openness' of these newer carriages is not for him. He likes to smell the air – the diesel – as it snakes in from outside. His badges tell of earlier campaigns and allegiances; his 'Ian Allan' lists the falling and the fallen – *Western Yeoman, Western Ruler, Western Hero*. Still a few more to get, but now they'll be found at Swindon. In the Graveyard. The Graveyard of the Diesels, where these once-fêted beasts sit forlorn, their fading paintwork so suggestive now of fading, faded life. Later, walking round the cindered sidings, there'll be engines he'd have waited all day to see. Their days now done, he notes the numbers, takes a photo and

Above: Away from the glamourous HSTs, London termini still teemed with commuters opening doors and jump-running to platforms before their trains came to rest. This was made possible by older slam-door stock like the Class 418 electric multiple unit seen here. Their efficiency (if not their safety!) at detraining passengers helped extend their lives, particularly on Southern suburban lines.

Below: A grimy Class 31 with another grimy commuter train, this time at Farringdon in London. Like many of BR's older unit trains, the coaches – which date from the early 1950s – are non-corridor. Electrification in the late 1970s would see their replacement by open-plan electric multiple units.

clambers into a cab or two when no one's looking. Back at Swindon station, he sips tea from blue-green china, bites on an orange Club and thinks about getting home. A '125' pulls in, but he gives it a miss, preferring to wait for something more interesting. A multiple unit rasps in to the bay to bring the two sides of BR together, for while HSTs had let commuters live further away from their London offices, for every slick Mark III there was a rattling old unit, for every slick executive in Reading or Swindon there was a Reginald Perrin crammed into a slow train somewhere in the suburban outreaches of the Eastern and Southern Regions.

On the former, services from London's dingy Liverpool Street hadn't changed for over twenty years, with ninety-four trains calling at Gidea Park just as they had in 1955, 1965 and 1970; on the latter, the twenty-year-old Mark I electric multiple units had recently been augmented by even more, the Southern preferring the standardised approach where new builds were concerned. Each day tens of thousands of cowed commuters agonised over their mortgages from crowded compartments while their underlings clung to grab straps as they lurched over the points into Cannon Street, London Bridge or Waterloo. But both pitied the poor souls on the Great Northern route into King's Cross, who endured compartment trains with no corridors, where many an unwanted conversation was struck up as businessmen and women wound their way to work from Hatfield and Stevenage. It had all been so much worse in the stifling heat of that summer, when even short journeys became endurance trials. Thankfully for this last group, though, electrification was on the way.

Sanctioned by the government in 1971, progress had been hampered to some extent by management insistence that no more than six minutes' delay be imposed on inter-city traffic while the work was under way. And there was much to be done, including major alterations at King's Cross, new maintenance facilities at Hornsey, a new flyover at Welwyn Garden City and over fifty bridges, which had to be raised, renewed or reconstructed to make way for the overhead equipment. Nevertheless, full inner suburban services to Hertford and Welwyn Garden City began in November 1976, using BR's first 'second generation' electric multiple unit – the Class 313s, which were based on 'PEP' and featured smooth-riding bogies, rapid acceleration, and power-operated doors.

On the main line, of course, the boost electrification had been given by the success of the Euston–Glasgow scheme led BR to consider it in the wider sense once again. The difference now was that the East Coast's place at the top of the list had been taken by the St Pancras–Sheffield route, the Board anticipating government approval of the self-contained commuter section between London and Bedford. This came too in November 1976, but despite it – and more financial aid from the Passenger Transport Executives – it was clear that electrification had its limits. This meant that many suburban and rural services were forced to use diesel units that were well past their best. While some travellers still loved the forward-facing views that were possible – and which had been such a selling point when these trains were introduced in the 1950s – they rattled and shook, and were (to many) best avoided. The solution – *a* solution – would come, but in the meantime a refurbishment plan for the best of the old stock was begun, involving replacement engines, modern upholstery, new floor coverings, new toilets and fluorescent lighting.

These stories all graced the railway press as the year drew to a close, its scorching summer replaced now by the usual cold, the usual rain, usual greyness. One December story stood out for all the wrong reasons, relaying as it did a crime that had occurred a few weeks before: a heavy object – thought to be a brick – had been dangled from a bridge near

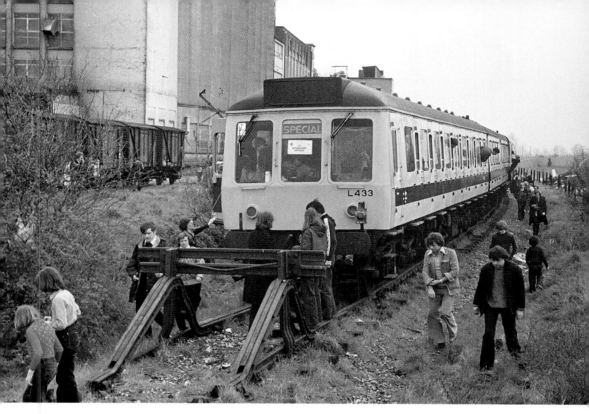

With little or no money for more electrification or renewals in the mid-1970s, BR decided to refurbish its aging diesel multiple units. The programme lasted from 1975 to 1983, with completion usually being denoted by the 'white and blue' livery sported by this Class 117, seen on a special at Wallingford in 1976. (Colour-Rail)

Swindon. It was struck by an HST service to Swansea. The driver escaped serious injury, though the windscreen was smashed and the train taken out of service. At the same time, BR was reporting a 15 per cent rise in passenger receipts. Parker was pleased, but knew more success was needed if other obstacles – real, metaphorical and political – were to be avoided in the months ahead.

6
Silver Jubilee

You'd missed the end of steam on the Southern. You'd missed the end of steam full stop. You'd even missed the end of steam on the Met's engineering trains in London. But now you're older, life's moved on, and you're here for the end of the Westerns, those elegant diesel-hydraulics quite unlike anything else on the network. As time had passed and flares had widened, love for these non-standard beasts had grown – just as BR's need for them had ebbed. With their curtain call on the horizon, there'd been books, there'd been articles, there'd been tours galore: the 'Westerns South Western', 'Western China Clay', 'Western Talisman', 'Western Memorial', 'Requiem', 'Farewell', 'Lament', 'Finale'. You'd ridden them, read of them, photographed them. But the spirit of '76 was turning sour in '77 – their time was nearly up...

The end is nigh as Class 52s D1013 *Western Ranger* and D1023 *Western Fusilier* bring the 'Western Tribute' railtour into Bristol Temple Meads on 26 February 1977. (Rail Photoprints)

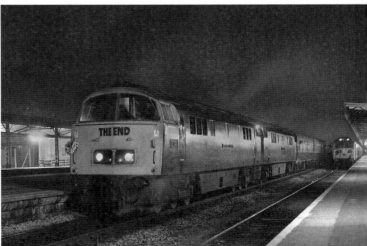

It's around 21.15 on 26 February 1977, and with the suitably adorned D1023 now leading, the 'Western Tribute' tour prepares to leave Taunton for the final run back to Paddington. (Rail Photoprints)

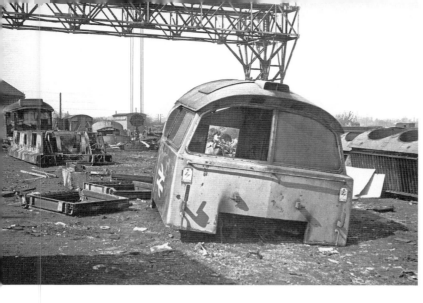

D1013 and D1023 would both be preserved, but not all 'Westerns' were so lucky, as this shot of D1052 *Western Viceroy* at Swindon shows. (Rail Photoprints)

It's Saturday 26 February, it's half eight, it's sunny, it's cold and you're at Paddington for BR's own 'Western Tribute'. The action's all on Platform 2, where a phalanx of spotters, railfans and enthusiasts throng the twelve good coaches and true, each vying for a view of Westerns *Ranger* and *Fusilier* at the country end. Cameras click, microphones rise, rubbings are taken – you'd think the nameplates were fifteenth-century church brasses.

Departure came with an almighty roar, as the mighty duo drew the train over the points at Paddington's station throat. By the time they returned – having taken in Swindon, Bristol, Bridgend, Swansea, Plymouth, Taunton and Reading – it would be twenty to midnight. *Fusilier* would return to its birthplace to be preserved for the nation and *Ranger* would make for Laira, where it would shunt a few wagons on the Monday morning before towing the 'Tribute's' two understudies – *Campaigner* and *Lady* – to Newton Abbot. When the driver powered down, took out the master key and climbed from the cab, that was it: *Ranger* would range on BR no more.

Did you know?

As diesel-hydraulic locomotives, the 'Westerns' used a torque converter to convey power from the engine to the wheels. In 1953, BR had decided to test a pool of them to measure their performance against diesel-electric machines (in which the engine is connected to a generator that produces the power to drive the traction motors). The Western Region agreed to host the trials.

Though the '52s' and some of their five counterparts were largely successful, all the other regions were equipped to maintain diesel-electrics, which were also cheaper to build and maintain. In 1965, BR deemed the latter to be the most suitable for its operating conditions. Withdrawals of the former thus began; by April 1975, the 'Westerns' were the only type left in service. As they lacked the room to house the electric train heating (ETH) equipment required by Mark IID carriages, and as more of their work was taken (first by ETH-fitted Class 50s usurped from Anglo-Scottish services by electrification, then by brand-new HSTs), their numbers fell until the last were withdrawn in February 1977.

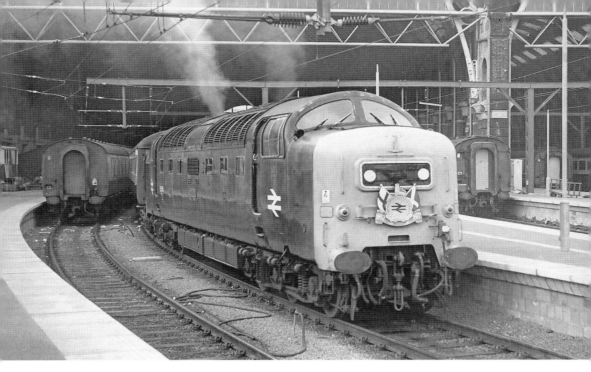

No. 55015 *Tulyar* awaits departure from King's Cross with the 07.45 to Edinburgh, named the 'Silver Jubilee' to celebrate twenty-five years of the Queen's reign. The return working left the Scottish capital at 15.00. (Rail Photoprints)

The End was covered on the local television news – it was covered in the *Guardian* for goodness' sake. No one had shed many tears when BR's early diesel failures had been withdrawn, but those had died in the days of steam. The Westerns might have seen off the Great Western's mighty 'Castles' and 'Kings', but for younger believers they were a favourite and their loss was much mourned. Of course it all made perfect sense if you were trying to run a railway, but it was hard to deny that the images of dead, decaying locomotives, disposed of before their useful life had ended, reflected somehow the state of Britain in this era of rising prices, falling pay and international loans sought by a government trying to loosen the economy's tightening grip.

Hardly an inspiring milieu for the Queen's Silver Jubilee, and at first there was understandably little enthusiasm for celebrating the twenty-fifth anniversary of Her Majesty's accession. The papers reported cancelled street parties while ministers argued over what gift the cabinet should bestow. The Prime Minister – James Callaghan – was enthusiastic, though, and as winter gave way to spring, patriotism began to be aroused, communities exploding in a riot of buntings, buns, pastries, and pennants. BR's part in the celebrations took many forms: the Royal Train was refurbished and augmented by two Mark III vehicles that May, the Eastern re-introduced the 'Silver Jubilee' express from 8 June, while the Southern linked its station displays with the Navy's fleet review at Spithead later that month (to which Sealink added the Channel Islands ferry *Sarnia*). Less formally, Stratford Depot turned out Class 47s No. 163 and No. 164 with silver roofs, silver buffers and large bodyside Union Jacks, while on the Great Northern the *North Herts Gazette* chartered the first-ever public electric train from Hitchin to Moorgate.

But what else? What of the HST? The HST was BR's 'shop window for Britain', to be mentioned in the same breath as Concorde. While already successful, Parker knew the government needed to be convinced that 'planned investment in the high speed project' was vital if rail was to 'remain a significant part of our domestic transport scene'. So why

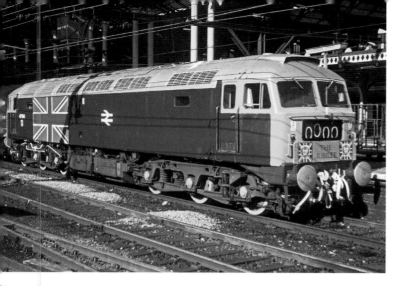

Stratford Depot's take on the Jubilee was to apply Union Jacks to two of its Class 47s. Here, No. 47164 waits at Liverpool Street with 'The Jubilee' service to Norwich on 8 June 1977. (Rail Photoprints)

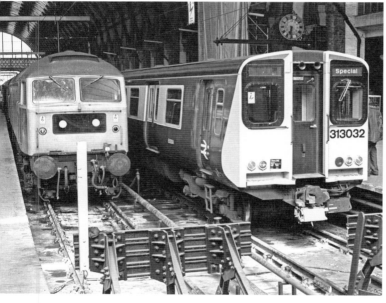

Class 313 electric multiple units – derived from the 'PEP' design of 1972 (see page 21), and as seen here at King's Cross – had been introduced on Great Northern inner suburban services from November 1976. By 1977, BR could report increases in passenger loadings and passenger receipts on the route (though the units' 'passenger-initiated' sliding doors didn't always work as designed). (Rail Photoprints)

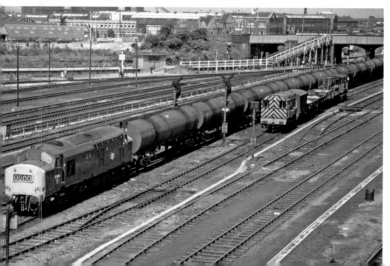

In 1977, BR renewed its contract with Phillips-Imperial for the movement of refined petroleum products from the latter's refinery at Port Clarence to clients and distribution points in the Midlands, North West and North East. Later that year, No. 37283 takes a tanker train through Doncaster while No. 08100 waits on the adjacent loop. (Colour-Rail)

not combine the two? Why not prove the HST's value and celebrate the Jubilee by making a high-speed trip to the capital with one of the brand-new trains?

The WR's summer '77 timetable had more services rostered for HSTs than hitherto, and more with planned average speeds of between 96 and 98 mph. The golden ton was something else, however, so the idea was developed to make what became the 'Inter-City 125 Jubilee Special' the first train publicly scheduled to run at a start-to-stop average speed above that figure. In the run-up, operations staff made adjustments to clear the way and minimise delays, although the nearer they got to London, the more traffic would cross their path. It was going to be quite a challenge, but by 7 May they were ready...

That morning, Driver Bill Francis and his mate Ron Sandercock signed on at Bath Road shed before walking across the avoiding line bridge to St Philip's Marsh Depot. Their charge, No. 253 019, gleamed in the Bristolian sunshine as they made their checks and stowed their gear. Francis moved his master switch to 'ENGINE ONLY' and made sure the power car's indicator lights came on. Seeing all was well, he pressed and held the Engine Start button, bringing '019 immediately to life before he 'opened up' and they headed for North Somerset Junction and Wyatt's great train shed.

On the platform at Temple Meads was all anticipation, all excitement, as doors were opened and those with tickets climbed aboard. The signal cleared, the 'right away' given,

Table 127

Inter-City 125
London Slough Reading
Didcot
to and from
Swindon Bath Spa Bristol
Weston-super-Mare
and Railair Link Reading-Heathrow

Train Services 2 May to 2 October 1977

Silver
Jubilee
1952-1977 Year

BRISTOL TO LONDON
IN 70½ MINUTES

A special Inter-City 125 train will run on
SATURDAY 7 MAY
between Bristol Temple Meads and London Paddington, scheduled to
travel at an average speed of 100 m.p.h. in each direction.

£10 1st class children (3 and under 14) (half fare) 2nd class **£7.50**

including
* commemorative gift with retail value of at least £1.50
* specially printed wallet containing souvenir travel ticket and card showing point to point train times for the journey
* "named" reserved seat in each direction
* Lucky ticket draw

Train times

Bristol Temple Meads	09 46	20 55
London Paddington	10 56½	19 45

Refreshment facilities.

Tickets available
from Temple Meads Station Travel Centre.
BR(W) WE9077. Subject to alteration or cancellation.

Above left: On 2 May 1977, the Western Region published its new timetable for the summer. Featuring a '125' on the cover, it included more services rostered for HSTs than hitherto, and more with planned average speeds of between 96 and 98 mph.

Above right: BR's official advertisement for the special high-speed run on 7 May 1977, as described in the text. To add to the sense of occasion, all passengers received a gift (either Fry's Jubilee Assortment chocolates or HST woven ties), in addition to BR's souvenir tickets, pamphlets and matches.

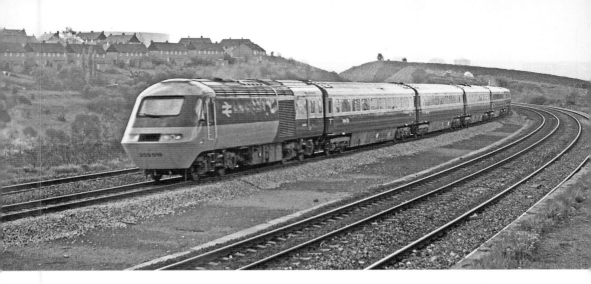

With Driver Bill Francis at the controls, No. 253019 passes Ashley Down as it climbs out of Bristol on the first leg of its record-breaking run on 7 May 1977. (Rail Photoprints)

the old tradition still part of the new as departure came at 09.46 and the train took its 360 passengers through Stapleton Road en route to Bristol Parkway. On board was a cacophony of clicking stopwatches and scribbling nibs, as every inch of the train's progress was recorded and debated. And it wasn't long before high speeds were attained: 97 mph came at Westerleigh Junction; by Hullavington, they had the full 125.

At Wootton Bassett, Bill Francis handed over the controls to his mate. The stretch from there to Swindon was scheduled for four minutes, but '019 managed the 5.6 miles in just over three-and-a-half. Didcot was passed at 126 mph, which (after a dip through Reading) climbed to a high of 127 between Maidenhead and Southall.

Arrival at Paddington came just before 10.55, 117.6 miles, and (more importantly!) sixty-eight minutes and twenty-three seconds after departure from Bristol Temple Meads. With an average speed of 103.3 mph, Messrs Francis and Sandercock had set a new world record for diesel traction over a run of this length. As they climbed down from the cab to the platform, they found themselves profusely thanked by passengers keen to obtain their autographs. O. S. Nock described the achievement as 'another step on the ladder of railway progress'. He was right – but there was more to come...

Driven by Bill Jones and Albert Williams, also of Bristol Bath Road, the Down working set off from Paddington nine hours later. By Ealing Broadway, the train had reached 101 mph; by West Drayton it was 124. The HST was soon gaining on its previous best, reaching 128 at Twyford and, between Didcot and Challow, achieving its fastest point-to-point average that day – an impressive 127.3 mph. While checked by speed restrictions at Wootton Bassett, Bristol Parkway and Stapleton Road, Temple Meads was reached in sixty-seven minutes and thirty-five seconds – an overall average speed of 104.4 mph. The morning's record had been broken, though soon there would be the promise of more – not with the HST, but something rather more advanced...

On 22 June, BR took delivery of the first prototype APT power car from BREL's Derby Works. The fuel crisis had made gas turbine propulsion unacceptably expensive, forcing the company to consider electric traction for its three planned 'APT-Ps'. Two 4,000 hp units were needed for 150 mph and above, but it was found that positioning them fore and aft like the HST would cause current collection problems, as the pantograph of the leading vehicle would disturb the overhead wire too much for the rear one. The solution was to marshal them both

Above: The delivery – over fifteen years – of around 55 million tons of coal from pit to power station was secured by BR in 1977. Most of this traffic would use the 'merry-go-round' system, but some more traditional flows continued, as exemplified by this working, which is seen at Chester that September with No 40105 in charge. (Rail Photoprints)

Below: In 1977, British Rail announced that all its Class 50 and Class 87 locomotives would be named. The unadorned No. 50023 – seen leaving Bath – became *Howe* at Plymouth's Laira Depot in May 1978. (Rail Photoprints)

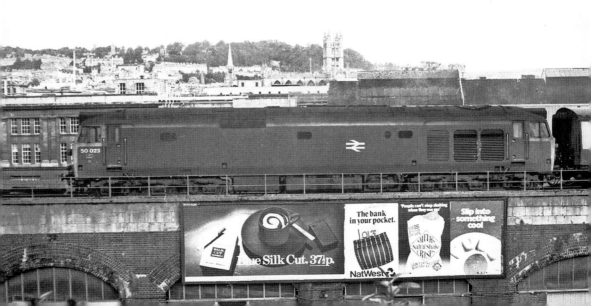

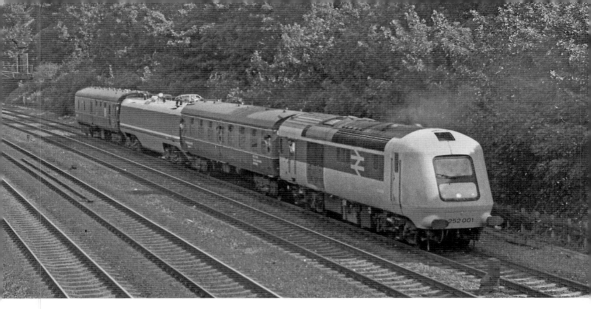

In June 1977, BR took delivery of its first prototype APT power car. Tests saw it sandwiched between a laboratory vehicle and a generator coach. Motive power was supplied by one of the now-redundant HSDT units. It was hoped that regular trains of over 150 mph would soon ply the West Coast Main Line. (Rail Photoprints)

SPEEDLINK
THE FREIGHT NAME FOR RELIABILITY

A booklet produced by BR for the launch of the Speedlink network in October, listing the timetabled services available, the types of wagon that would be used and the contact details of the company's Freight Managers.

in the middle of the train, although this effectively severed it in two, creating an expensive need for two catering vehicles and two crews. All the same, with the first rake of trailer cars already on their way, tests began that September.

It's fair to say that speed was something of a buzzword for BR at this point, its cachet even extending to the freight side of the business: that same month, Peter Parker broke a bottle of Guinness over an air-braked wagon at London's Marylebone station, marking the ABN's metamorphosis into the 'Speedlink' network. The government had approved a five-year rolling programme of wagon and locomotive building, so it seemed like the right time to try to turn 2 million tons of wagonload traffic a year into 4. Guinness were early customers, and as their black liquor dripped from the wagon that formed part of an exhibition train set to tour the country, there were hopes that the number of Speedlink services would rise from twenty-nine to around fifty.

Would they?

Only time would tell.

7
Dawn of a New Age?

Triumph or disaster; sink or swim. The stuff of nightmares, the genius of engineers. In 1928 and 1953, the former had won. Something had to be done. The trouble was the sweet Thames didn't always run softly. The trouble was the Thames was tidal to Teddington. A swell had seen large parts of East London submerged in 1928, killing fourteen people, but over 300 drowned twenty-five years later when a high spring tide combined with a severe storm over the North Sea to send a surge across Lincolnshire, Norfolk, Suffolk, Scotland – and Essex. Talks were held, decisions were made, strategies were formed, a solution was found. Eventually.

The first flood control proposals had been blocked by the need for an opening large enough to let vessels from the London docks pass through, but when containers came in and Tilbury was expanded, a smaller barrier became feasible. In 1974, excavations began at New Charlton, where the banks were relatively straight and the underlying river chalk strong enough to support the structure. In February 1978, BR started carrying limestone blocks to the site from Staffordshire. The trains were heavy, and passed through residential areas like Twickenham at night. Houses shook. Sleep was destroyed. Questions were asked in Parliament. The Secretary of State for Transport was aware. The Secretary of State for Transport was sympathetic. The Secretary of State for Transport – Bill Rodgers – said everyone wanted BR 'to carry more freight', but stressed that there were 'penalties involved, particularly on lines that are heavily used by day'.

In February 1978, BR started transporting limestone blocks for the Thames Barrier construction programme from Cauldon Low in Staffordshire to Angerstein Wharf in London. Limestone was also transported from Tunstead to Northwich on behalf of ICI, as this shot of No. 25110 at Northwich shows. (Rail Photoprints)

This badge was produced to advertise Great Northern electrification. Services encompassing the outer suburban reaches of Potters Bar, Hatfield and Royston began in March 1978.

Triumph and disaster. Sometimes it must have felt like the railway couldn't do right for doing wrong. But then, the same could have been said for the government. Or governments. The 'containerisation' that allowed work on the barrier to begin had tied in with Beeching's 'liner train concept', which looked so promising – some said – that Whitehall took just over half of Freightliner away from BR and gave it to a new National Freight Corporation. By 'Jubilee year' – eight years later – a Select Committee was having second thoughts, believing the business could be revitalised if it went back to BR to become more obviously linked to the latter's other non-passenger activities. And it certainly needed something, Freightliner having racked up losses of £13.9 million by the time the railway took control again in August 1978.

Still, the deep-sea traffic was so buoyant that even Southampton–London was a viable operation,

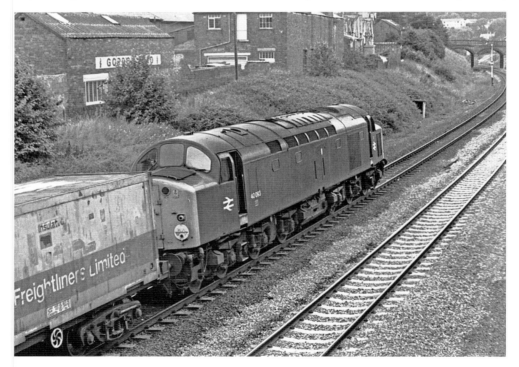

A Freightliner passes Colwyn Bay in July 1978, with No. 40093 in charge. At this time, a normal Freightliner grossed 1,070 tonnes. Aiming at 1,500, the first twenty-five-car train worked the Nottingham–Glasgow service (albeit with a restriction on the weight of the container contents). Route availability was also being sought for new 8-foot 6-inch-high containers. Work to bring the latter to fruition would soon begin, though it would not be without consequence. (Rail Photoprints)

despite the former being only 80 miles from the latter. Elsewhere, Tilbury was opening a new deep-water berth for large container ships at Northfleet Hope and the government was awarding a £412,000 grant towards the cost of a container terminal at Seaforth Dock – a project that helped boost rail freight in Liverpool at a time when conventional wagon traffic to and from the port had stopped completely. On the East Coast Main Line, moves were afoot to allow 8-foot 6-inch boxes to be carried, moves which would involve lowering the track in the tunnels at Stoke, Peascliffe and Penmanshiel. First, though, the route of the 'Flying Scotsman' would play host to the new order, the highest order, the High Speed Train, which had taken over six services in May (including the 'Scotsman' itself). Now, Eastern Region passengers could marvel just as their Western counterparts had done. Now, mothers, brothers, sisters, lovers and others heading from Newcastle to London could enjoy the swish of the saloon door, the softness of the seating and such bounty from the buffet. The ER had been disappointed not to receive a full roster initially, but found that many people were willing to wait for a '125' even if it meant standing for part of their journey.

By this time, the combination of higher speeds, more services and better ticket deals – like the 'AwayDay' (1976) and '17 Day Return' (1977) – were starting to reinvigorate express travel. And what with the Great Northern electrics bringing more passengers in from the outer suburban reaches of Potters Bar, Hatfield and Royston to King's Cross, more electrification on its way to the Argyle Line and Mark III carriages on their way to Glasgow–Edinburgh services, it was clear that the future was brightening beyond the world of Inter-City. Indeed, Parker would be able to announce a surplus of £58.3 million in the Board's 1978 Annual Report, and point out that the financial objective agreed with the government had been improved upon for the third year running. It all seemed a far cry from the fears voiced in earlier reports that BR's 'crumbling edge of quality' would widen. And yet...

Class 47 No. 47100 waits at Bristol Temple Meads with the 23.57 Glasgow–Bristol 'sleeper' on 21 May 1978. The Mark I carriages are of the same type that would be involved in a fire near Taunton some six weeks later. (Rail Photoprints)

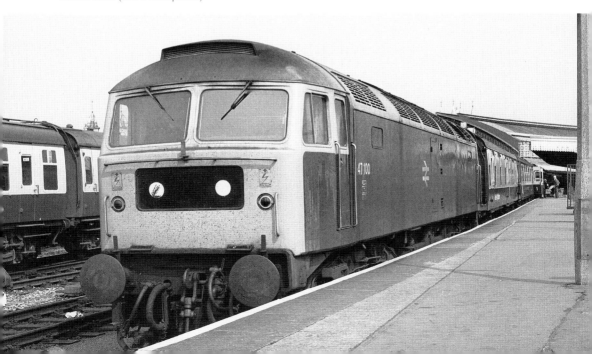

Perhaps there'd been too much triumph. Perhaps there was always going to be disaster. The Taunton sleeper fire (see below) had shown the need for a new Mark III design to replace the inadequate Mark I sleeping cars then in use, but the New Year would bring new tragedy to halt all Mark III traffic, all freight traffic – traffic of all kinds – on the racetrack that linked Leeds, Doncaster, York and Newcastle...

Did you know?

Though 1976 and 1977 had seen no passengers killed in train accidents, the same could sadly not be said for 1978, whose worst incident came when a fire broke out on a 'sleeper' in Somerset.

At the time, BR was carrying some 800,000 sleeper passengers a year, using steel-bodied Mark I coaches dating from 1957. Popular with passengers, their poor fire resistance was underscored all too clearly on 6 July, when linen bags placed against an unprotected electric heater caught fire near Taunton, resulting in the deaths of twelve people. Most of the issues raised by the accident would be addressed by new Mark III vehicles, which were authorised in 1979 and would feature better signage, refined fire alarm systems and smoke detectors. Introduced from January 1982, over 200 would eventually be built.

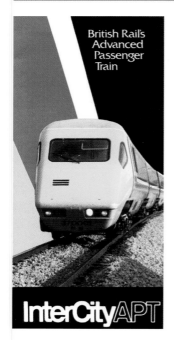

British Rail's Advanced Passenger Train

InterCityAPT

A leaflet promoting the 'prototype' APT (APT-P), which was introduced for testing in May 1978.

You could say it was the price of progress. You could probably say something about consumerism. Either way, the need to use bigger containers had meant work, work that had gone well at Stoke, gone well at Peascliffe. It started well at Penmanshiel too, the floor of the Up line having been dug out and new track laid on a concrete base by 10 March. All trains were then routed via the 'Up' so the focus could shift to the 'Down', whose floor was soon lowered, and the site prepared for the next stage.

Fifteen people, five items of plant, seven days later. Fifteen people, five items of plant were in the tunnel early on Saturday 17 March. Three excavators were trimming the rock profile, another was loading loose rock into a dumper truck, yet another was standing by. From the edge of the concrete, the Works Inspector shone his torch towards the tunnel wall. Expecting routine, he got a shock, small pieces of rock seeming to burst from the vertical face. There was only one thing to do: shore up the wall. He set off to make the arrangements. He heard a crash. He turned. He saw... The crown had collapsed, and the space had become blocked by a scree of broken pieces. He'd been lucky. So had twelve of his men. Not so the excavator operator and dumper truck driver.

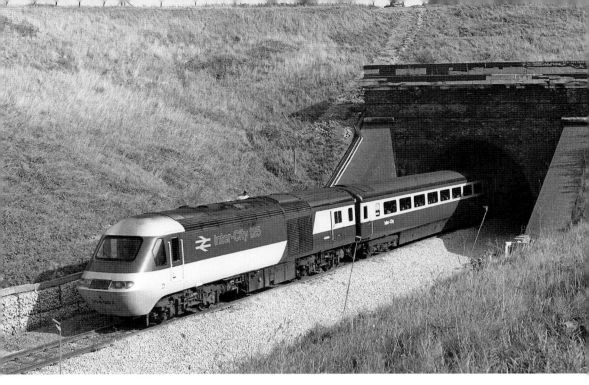

HSTs were introduced to the East Coast Main Line in May 1978. Here, No. 254007 is seen at Stoke Tunnel that September, running 'wrong line' with the 14.00 Kings Cross–Edinburgh, the Down line having been removed to allow the track to be lowered in readiness for Freightliners carrying 8-foot 6-inch containers. (Rail Photoprints)

The accident was investigated, but the causal chain was never fully established, so much evidence having been destroyed in the crush. The lives of those left behind were destroyed too. So too was the timetable, the East Coast Main Line effectively being severed between Berwick and Dunbar. At first, HSTs worked from King's Cross to the former, buses taking passengers on to the latter, where conventional trains waited to carry them to the Scottish capital. Some Euston services also ran to Edinburgh and Aberdeen, though the much-needed engineering solution was soon sought – and found. On 8 May, Sir Robert McAlpine's men started on a new diversion line with such urgency that it was able to play host to a ceremonial HST run on 20 August. Triumph over disaster. Still, there was more than one type of triumph, more than one type of disaster.

There were public relations disasters, for example. BR had started to gain a reputation not only for curly sandwiches and dirty seats, but also poor service and surly 'storm-trooper' staff – off the Inter-City network, at least. 'Your travelling public,' says Fred, protagonist of 1978's training short *It Takes All Sorts*, 'couldn't care less how we treats 'em. All they cares about is catching them bloody trains!' Fred – the sort of miserable, world-weary, cantankerous every(rail)man imagined by sitcom writers – is wrong. The narrator tells him so. The trouble was, while he might have been at home in *Citizen Smith* or *Some Mothers Do 'Ave 'Em*, he was real enough for BR to feel it had to point out that passengers had a choice about being passengers – they could so easily choose to be motorists, and it was hard enough to persuade them not to be without the front line pushing them away too.

Then of course there were accounting disasters, both freight and parcels showing a combined loss of £3 million for 1979, iron, steel and petroleum in particular being between

Above: In October 1978, the Queen formally opened Liverpool's 'Merseyrail' network, which had been completed when an interchange between the Northern and Wirral lines was finished at Moorfields that July. Class 502s and 503s of late 1930s vintage initially featured, though they were slowly replaced by 507s and 508s. Here, a '502' is seen at Sandhills. (Colour-Rail)

Below: The first Southern-based Class 508s, like No. 508038 – seen here at Clapham Junction – entered service in 1979. Note its resemblance to the '313', the main difference being that the '313' collects current from 25 kV AC overhead wires, while the '508' is powered from a 750 V DC third rail.

Above: On 1 March 1979, ex-GWR 'King' No. 6000 *King George V* worked a special train from Paddington to mark the 125th anniversary of Brunel's great station. Sadly, the engine developed a hot axle box and was laid over at Didcot. The HST alongside had better luck, the 'Inter-City 125' network being destined to reach Plymouth and Penzance in October that year. (STEAM Museum)

Right: A leaflet produced by Travellers-Fare in 1979 to mark the hundred years since the Great Northern Railway had launched the first dining car on Britain's railways. Accordingly, a special train of vintage carriages ran from Leeds to King's Cross on 13 September.

15 and 20 per cent down on the figures recorded seven years before. And though 'Section 8' grants had been a valiant attempt to improve things, once freight had been lost to the roads it was almost impossible to win it back again. Thus, while forty-one grants had been awarded by the middle of 1978 – representing a shift from road to rail of 6 million tons a year – over three times the number of private sidings closed as opened in the same period. Rising inflation – and the pressure this put on BR to put up prices – made it hard to strike the right balance for the customer, and the customer was king, the Board being all too aware that if the tariff was too high, traffic would tumble. Add to that the fact that Travellers-Fare, the hovercraft division and BREL were hardly setting the world on fire either, and it was clear that what was needed was hope. And there – on the West Coast Main Line, just as at the end of the 1960s – it was.

Imagine, then, being a railway executive four days from Christmas 1979. You're at Euston, its cold, and as you sip a coffee in the warmth of the restaurant, you look down on the concourse at the milling millions. It's all a bit shabbier now than the heady days of a decade before, but still they come, still they travel – the business types, the wealthy types, the pupils, the odd punk or two. The odd railway type too. Your own train's being prepared, but so's breakfast – frying on Friday – and as you await the arrival of bacon, egg, sausage and tomato, you turn to the two documents on the table in front of you: that day's *Times* and a copy of *Challenge of the '80s*, which had just come out, and which the Board had produced to show their aim to develop the railway's commercial strengths, while stressing the need to reform the operation and manning of trains, terminals and engineering establishments. The hope was that such promise of productivity increases would help Mrs Thatcher's new Conservative government smile on the idea of investing in BR. You pick up *The Times*.

Turning to page 4 you see the story you knew would be there: 'Tilting train sets 160 mph record,' it read. The run had been 'extremely smooth,' the driver said. You know a bit more.

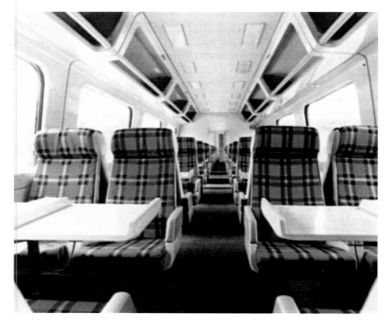

The snazzy upholstery of a First Class APT-P saloon, as fantasised over by the BR executive mentioned in the text. In Second, a blue tartan was the order of the day. Note that having the power cars in the middle of the train also created a need for two sets of First, two sets of Second, crew and catering facilities and so on.

Did you know?

By 1977, the Class 27s that 'topped and tailed' Edinburgh–Glasgow services were suffering high failure rates. BR announced a forthcoming upgrade, which materialised in new rakes of Mark IIIs worked by Class 47s specially adapted so they could be driven from their own cabs or from a lightweight driving trailer (converted from a Mark II coach) at the remote end of the train. Entering traffic from October 1979, they retained the operational advantages of the earlier push-pull system, but the 100 mph capability of the '47s' – coupled with the comparative luxury of the 'HST' coaches – offered a step-change in service quality for passengers.

A Class 40 and a '25' flank a 'driving brake second open' or 'DBSO' at Glasgow Queen Street in 1979. The new push-pull service, brought in to replace ailing Class 27s (see page 15), began that October. (Colour-Rail)

You know this is the train of the future. You can't wait to see its stylish livery, its stylish tartan seating, for yourself. You hope it will coax long-distance passengers back from the air. You hope.

The record-breaking run had come near Quintinshill, scene – in 1915 – of the worst train accident Britain had ever known. Triumph where once there'd been disaster. The seventies railway had seen elements of both. You tuck into your breakfast, look down at the concourse again and smile. The new decade was looking good. The new decade could be the age of the train. Couldn't it?

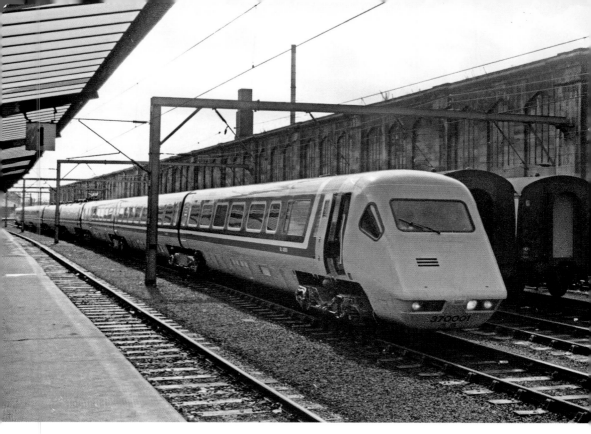

Prototype APT No. 370001 arrives at Carlisle during a test run on 13 August 1979. On 20 December, the train reached a record-breaking 162.2 mph between Quintinshill and Beattock. The record would stand for twenty-three years. (Rail Photoprints)

8
What Now?

Reading and Viewing

This book is intended to be a summary of British railway history in the 1970s and is not, therefore, an exhaustive survey. More detailed information may be found in the following volumes:

Bonavia, Michael R., *British Rail: The First 25 Years* (David & Charles, 1981)

Boocock, Colin, *Spotlight on BR: British Railways 1949–1998 – Success or Disaster?* (Atlantic, 1998)

Gourvish, T. R., *British Railways 1948–73: A Business History* (Cambridge University Press, 1986) – essential reading for all students of the railway.

Gourvish, T. R., *British Railways 1974–97: A Business History* (Cambridge University Press, 1986) – as per the above.

Haresnape, Brian, *British Rail 1948–1978: A Journey by Design* (Ian Allan, 1979) – covers the design development of locomotives, rolling stock, coach interiors, uniforms, ferries, stations, typefaces and so on.

Johnson, John and Long, Robert A., He A *British Railway Engineering 1948–80* (Mechanical Engineering Publications Ltd, 1981) – the engineering story, told by engineers and verified by those who were actually there.

Marsh, Richard, *Off the Rails: An Autobiography* (Weidenfeld and Nicolson, 1978) – the first BR Chairman to write his own story, Marsh (1971–76) details his early life and his time in Parliament before discussing the joys and frustrations of running British Rail.

Parker, Sir Peter, *For Starters: The Business of Life* (Jonathan Cape, 1989) – Parker's autobiography includes insights into his refusal to take the BR Chair in the 1960s and his struggles to secure investment.

Wojtczak, Helena, *Railwaywomen: Exploitation, Betrayal and Triumph in the Workplace* (Hastings Press, 2003) – a book of pioneers, of which Wojtczak was one, becoming the first female guard to be employed by British Rail in 1979.

Wolmar, Christian, *Fire and Steam: A New History of the Railways in Britain* (Atlantic Books, 2007) – sets the 1970s in the wider rail history context.

The British Film Institute has released a number of British Transport Films' finest documentaries on DVD, including those mentioned in this book, like *The Finishing Line* and *It Takes All Sorts*. They are available from a variety of online and high street stores. Other films available on DVD include:

Get Carter (1971) – revenge film with Michael Caine, which begins with his character taking a First Class trip from London King's Cross to Newcastle, as referenced in Chapter 3. The scenes feature many elements gone from today's railway, like corridor trains, smoking in the compartment and white-waistcoated waiters serving four-course meals in the

restaurant car. The film was shot long before the East Coast Main Line was electrified, at a time when it was still controlled by a forest of semaphore signals and when the station name boards at Newcastle still wore the tangerine background of BR's North Eastern Region.

Night Ferry (1977) – Children's Film Foundation crime drama with Bernard Cribbins. Scenes include traditional hump shunting, typical mid-1970s Southern Region commuter trains, and the celebrated London Victoria–Paris 'Night Ferry', a service which would run for the last time in October 1980.

Web Resources

The National Archives: www.nationalarchives.gov.uk
The National Archives – formerly the Public Record Office – has an online catalogue, listing its collection of official and business-related documents. Copies of some items may be ordered through the site. Visits may also be arranged.

The Railways Archive: www.railwaysarchive.co.uk
Most of the source documents referred to in this book – including the reports on the West Ealing (1973) and Penmanshiel Tunnel (1979) accidents – may be downloaded free of charge from this important online resource.

RailServe: www.railserve.com
This is a comprehensive guide to 19,000 railway websites and upcoming events. It features 180 categories, spanning railway travel, railway enthusiasm and the railway industry.

Search Engine: www.nrm.org.uk/researchandarchive
The National Railway Museum has an extensive online library and archive. Catalogues list details of the museum's extensive collection of papers, drawings, reports, timetables, photographs and so on. Copies of many items can be ordered through the site.

Places to Visit

Museums
Barrow Hill Roundhouse Railway Centre, Campbell Drive, Barrow Hill, Chesterfield, Derbyshire, S43 2PR. Telephone: 01246 472450. Website: www.barrowhill.org
Britain's only surviving, operational roundhouse engine shed; frequently holds modern traction events.

Crewe Heritage Centre, Vernon Way, Crewe, Cheshire, CW1 2DB. Telephone 01270 212130. Website: www.crewheritagecentre.co.uk
Includes the APT-P, among other modern traction exhibits; also offers the chance to drive a diesel locomotive on its demonstration line.

National Railway Museum, Leeman Road, York YO26 6XJ. Telephone: 01926 621261. Website: www.nrm.org.uk
Home of HSDT power car No. 41001.

'Locomotion', the National Railway Museum at Shildon, Shildon, County Durham, DL4 1PQ. Telephone: 01388 777999. Website: www.nrm.org.uk/PlanaVisit/VisitShildon.aspx
Includes the APT-E.

Heritage Railways
Bo'ness and Kinneil Railway, The Scottish Railway Preservation Society, Bo'ness Station, Union Street, Bo'ness, West Lothian EH51 9AQ. Telephone: 01506 822298. Website: www. srps.org.uk/railway
Home to a large collection of diesel power common to Scotland during the 1970s.

Great Central Railway, Loughborough, Leicestershire LE11 1RW. Telephone: 01509 230726. Website: www.gcrailway.co.uk
The only double-track heritage line in Britain.

Llangollen Railway, The Station, Abbey Road, Llangollen, Denbighshire LL20 8SN. Telephone: 01978 860979. Website: www.llangollen-railway.co.uk
Operates a variety of steam and diesel locomotives, along with several 'first generation' diesel multiple units.

The Midland Railway, Butterley Station, Ripley, Derbyshire DE5 3QZ. Telephone: 01773 747674. Website: www.midlandrailwaycentre.co.uk
The Midland Railway Trust's large collection includes many diesel locomotives and multiple units from the BR era.

Nene Valley Railway, Wansford Station, Stibbington, Peterborough PE8 6LR. Telephone: 01780 784444. Website: www.nvr.org.uk
Home to some diesel locomotives and has plans to create a 'travelling post office' museum.

North Yorkshire Moors Railway, 12 Park Street, Pickering, North Yorkshire YO18 7AJ. Telephone: 01751 472508. Website: www.nymr.co.uk
Offers occasional 'diesel galas'.

Swanage Railway, Station House, Railway Station Approach, Swanage, Dorset BH19 1HB. Telephone: 01929 425 800. Website: www.swanagerailway.co.uk
Offers occasional 'diesel galas'.

West Somerset Railway, The Railway Station, Minehead, Somerset TA24 5BG. Telephone: 01643 704996. Website: www.west-somerset-railway.co.uk
A 26-mile heritage line through the Quantocks.

Many of Britain's heritage railways use locomotives, rolling stock and infrastructure that were built, manufactured or used throughout the 1970s. Some even host themed events around the era, details of which may be found in various books and magazines, as well as the Heritage Railway Association website: www.heritagerailways.com

Getting Involved

There are many railway societies, model railway societies and preservation societies in Britain. Here is just a small selection of some of the more general ones:

The Electric Society (www.electric-rly-society.org.uk) caters specifically for those interested in electrified railways across the world. It holds regular meetings in London and Birmingham.

The Historical Model Railway Society (www.hmrs.org.uk) was founded in 1950 by historians and modellers to collect and exchange records, drawings and photographs in the interests of historical accuracy in modelling. With around 2,000 members worldwide, it remains strongly committed to gathering and distributing UK railway information. It has a large collection of photographs and drawings, a large library and has published a series of definitive books, largely concentrating on railway liveries.

The Railway Correspondence and Travel Society (www.rcts.org.uk) caters for people interested in all aspects of railways past, present and future. It publishes a monthly magazine – *The Railway Observer* – organises local meetings, has a lending library open to members and produces books of enviable accuracy.

The Signalling Record Society (www.s-r-s.org.uk) maintains and shares knowledge of railway signalling and operation in Britain and overseas. It publishes books and possesses much archive material, including photographs and drawings that may be purchased. Modern material is being added to the digital archive regularly. Members are able to download some of the digital material free of charge.

Experiences and Volunteering

Heritage railways are only really possible because of the huge volunteer workforce that helps keep them running. From cooks to cleaners, drivers to guards, signal staff to station masters, most will be giving up their spare time to work gratis in an environment they love. If you are keen to join in, it is best to contact your chosen heritage line directly. For non-safety related roles, basic training will probably be provided, but anything involving the movement of trains is likely to require more rigorous preparation, the testing of one's understanding of operating rules and so on.

If, however, the experience of driving a train is sought on a more informal basis, many short courses are available that allow members of the public to drive a steam or diesel locomotive. Again, contacting individual heritage lines directly(via their websites) is the most effective way to find the right course for you.

Collecting

Railways were veritably made for collecting, from large items like locomotive nameplates – some of which can run to thousands of pounds – to smaller pieces like clocks or watches. For the larger ephemera, specialist auction houses (like Great Central Railwayana Auctions – www.gcrauctions.com) are recommended, though you can start a collection of tickets, timetables or postcards by visiting car boot sales, model railway exhibitions or any online auction site. Many railway enthusiast magazines include features on recent sales and high-value items of interest.